WILD
CITY

WILD CITY

A Brief History of New York City in 40 Animals

Thomas Hynes

Illustrated by Kath Nash

HARPER
DESIGN

An Imprint of HarperCollinsPublishers

Contents

Introduction

I have always loved New York City, but I honestly never really thought too much about its wildlife. I knew there were parks, but I highly doubted there was much "nature." Some rats and pigeons, sure, but not much else, nothing truly wild. After all, the concrete jungle is barely forgiving enough for human life, so surely this could be no place for the fragile intricacies of the natural world.

For me, all that changed one summer afternoon when I was running through Central Park. I turned somewhere in the Ramble and suddenly I was eye to eye with the biggest raccoon I had ever seen in my life. I screamed "OH MY GOD!" in English, just as surely as it shrieked something similar in Raccoon. I was shocked by its sudden presence, but most of all, I just couldn't believe something so wild had grown, survived, and continued to thrive in the middle of Manhattan.

This experience set me off on a mission to uncover all the amazing creatures hidden in plain sight in this seemingly unforgiving city. Along the way, I discovered stories of peril and perseverance, histories both notorious and sublime. The most surprising thing I discovered, however, is the vital role all these animals have played in New York City's history. Indeed, this city did not grow to such heights in spite of its surrounding nature but rather rose to become the most famous metropolis in the world *because* of it. The city owes everything—its legacy and its strength—to the surrounding wild world. These critters are not some footnote or historical aside to the saga that is New York City. Instead, these animals are the story; they are the city. And they always have been.

You see, way back, back before the arrival of the Dutch, back when this was Lenape land, New York City was overflowing with wildlife, including black bears, gray wolves, and fish of countless stripes. Eric Sanderson, in his *Mannahatta*, maps out how this region might have looked four hundred years ago, before the arrival of Henry Hudson, and posits that the city comprised then some "fifty different ecological neighborhoods," providing a stunning array of habitats and biodiversity. In other words, it's not enough to say that had it been left untouched, New York City could have been a national park. Rather, it would have been *the jewel* of the national park system, on par with Yellowstone or Yosemite.

But instead, the city went in the other direction, building up an urban landscape the likes of which the world had never seen before: a

Woodlawn
Cemetery

Orchard
Beach

Harlem
River

BRONX

Inwood Park

Bronx
River

**NEW
JERSEY**

N. Brother
Island

Hudson River

Central Park

MANHATTAN

Flushing
Meadows
Park

Long
Island City

Meadow
Lake

QUEENS

East River

Newtown
Creek

Forest Park

Railroad
Park

Brooklyn
Bridge Park

Gowanus Canal

BROOKLYN

Governors
Island

Greenwood
Cemetery

Rulers
Bar

Upper
Bay

*Jamaica
Bay*

Floyd Bennett
Field

Coney
Island

Dead Horse Bay

Jacob Riis
Landing

**STATEN
ISLAND**

Freshkills Park

Swinburne Island

New York Bight

Tugboat
Graveyard

Lower
Bay

testament to humanity's ability to transform and, yes, tame the natural world. To do so, it drew on its natural wealth, which was much more abundant than any other new American city on the Eastern Seaboard. Those other cities didn't stand a chance: Philadelphia has a port, sure, but it's about eighty miles inland; Boston has a port right on the ocean, but it is in no way protected; and Washington, DC, politics aside, is literally a swampy mess a hundred miles from the sea, where few people lived before 1800.

did. But money and dreams of wealth played a larger role. After all, the East India Company of the Netherlands didn't finance a permanent New Amsterdam colony in lower Manhattan just for the sake of liberty. The British didn't later wrestle that colony away from the Dutch and then make a strategic bid to hold it at all costs against the rebellious Americans just for the sake of freedom. Forget those patriotic fairy tales: cash ruled everything around Manhattan. And even back in the day, New York City was a moneymaker.

> **"**
>
> # The city owes everything—its legacy and its strength—to the surrounding wild world.
>
> **"**

New York City, on the other hand, is surrounded by broad and navigable rivers, protected by a series of barrier islands, and sits only seven nautical miles from the open ocean. You would be hard pressed to create a more ideal natural setting for a harbor city if you tried.

Things were even better on land, where there were fortunes to be made. According to American mythology, Europeans came to this continent, and this city, in search of freedom. And, sure, perhaps some

Early on, that meant beaver skins, as well as the pelts of otters, mink, and muskrats. Later, it was fish and oysters, more oysters than the world had ever seen.

Eventually, that small original Dutch settlement at the tip of southern Manhattan spread out in every direction, including up. The landscape was totally remade, all in the name of profit and progress, in the name of AMERICA! There was so much to be had back then that the supply seemed endless. There was no sense in worrying for the future.

Forbearance, prudence, conservation . . . forget about it. The trash could be burned, tossed into the wetlands, hauled out to sea, or, better yet, dealt with later. Surely the good times of natural prosperity, free from want, consequence, and repercussion, would last forever.

As the story goes, though, things went to shit, in some cases literally. The harbor was overfished and simultaneously inundated with human waste. The forests were cut down. The streams were paved over. The beavers were

ecological and natural gem the likes of which had never been seen before, was all but ruined.

By the time landmark environmental regulations such as the Clean Water Act of 1972 were enacted, a cross-species urban exodus was already under way. Indeed, it wasn't just the animals that were leaving. New York City's human population declined in the 1970s for the first and only time in its history, or at least since as long as such records have been kept. Many refer to this period as the city's dark days,

> **"**
>
> # Think of this book as a guide for curious, nature-starved New Yorkers hoping to spot the magic of urban wildlife.
>
> **"**

trapped, replaced with litter in their river habitats should they ever consider returning. The air was poisoned. Many birds were driven to the brink of extinction. The natural borders of the shoreline were pushed out until one constant bulkhead emerged, destroying countless habitats while leaving the city needlessly vulnerable to flooding. And the garbage: it was piled hundreds of feet high—higher than the Statue of Liberty—until finally the landscape was unsuitable for the natural world and barely any better for humans.

Incredibly, in that relatively short period of 350 years between the arrival of the Dutch to the end of the 1960s, New York City, once an

when those who could afford to do so left for the suburbs and those who remained endured a diseased city, a bruised apple rotting to its core. Pollution and environmental degradation were only part of the story, but by no means did they play an insignificant role in this blighted chapter of New York history. Nobody wanted to live in this mess, not the people, and certainly not the animals.

Wild City is a reminder of what happens when society doesn't consider how its actions play out downstream. These are the stories of those collisions between nature and our urban experiment. At times, this relationship has been

misguided; other times, it's been cruel. There have been quite a few surprises and plenty of unintended consequences. But this book is also a story of redemption, about a city once epitomized by blight and pollution that now towers above its peers as an example of balanced and sustainable urban living. Although it seemed like a long shot just a few decades ago, New York City actually has cleaned up its act, as well as its harbor, its rivers, and its parks. Real ecological amends have been made throughout years of hard-fought environmental crusades by advocates who had the nerve, grit, and vision to make the city a more hospitable place for all living creatures. Slowly yet steadily, many of the original native species have returned, accompanied by many new species, which are eager to try their hand (or paw, feather, or fin) at city living. And here, in New York City of all places, they have found a greener, cleaner, and healthier place to live.

As part of my research for this book, I paddled a canoe down the Bronx River in search of beavers, visited a hospital for pigeons on the Upper West Side, sought out parrots in a Brooklyn cemetery, tended honeybee hives on a Midtown roof, spotted peregrine falcons hunting above the East River, built artificial oyster beds on Governors Island, witnessed endangered birds darting along a rehabilitated landfill in Staten Island, moved quietly through a coyote's overgrown habitat in Queens, and watched with wonder as whales crashed among the waves just off the city's shoreline. I soon came to realize that the Central Park raccoon I encountered was no anomaly—it was a real New Yorker and, along with its presumed family and dozens of other critters, made up a crucial part of a wildly different New York City than I ever knew existed. And that's the city I hope to share here with you.

Think of this book as a guide for curious, nature-starved New Yorkers hoping to spot the magic of urban wildlife, who otherwise must squeeze from tight subway car to tiny apartment, who feel beaten down by the grind of the rat race, who maybe forget from time to time why living in the city is such a thrilling experience. Hopefully, these stories of enterprising and wild animals that endeavored to make it here will be a testament to all creatures' ability to thrive in the big city. Though it may be cramped and crowded, life does prevail here in New York City.

Where the Wild Things Were

efore meeting all the different wild critters of New York City, it might be helpful to take a quick tour through the city's boroughs and its recent ecological history, to see how things were originally, and how what remains tells the story of a city transformed through the centuries.

It should come as no surprise that the city is radically different today from that day in 1609 when Henry Hudson arrived. The contemporary version of New York City would also probably be unfamiliar from the day in 1789 when George Washington was inaugurated on Wall Street. Suffice to say a lot has changed. If those two men were somehow to set foot in the city today, they would first probably be terrified of all the cars and the noise. But were they able to calm down, they might also be astounded by how altered the landscape looks.

For starters, there is a lot more of the city today. By way of landfill and reclamation, including all the earth dug up to make way for subway tunnels, New York has bulged outward for centuries. As a result, the harbor is smaller, about three-quarters of its original size. According to Ted Steinberg's book, *Gotham Unbound*, there are approximately three Manhattans' worth of new land reclaimed from the water.

The city is divided into five distinct boroughs: Manhattan, Brooklyn, Queens, the Bronx, and Staten Island. Each borough varies in population and size and comprises its own distinct ecological zone and wild inhabitants.

Staten Island

Staten Island was the last part of New York City to be urbanized. Until as recently as 1900, there were more than eight square miles of marshland on this outermost borough. Today, there is a little more than one square mile. And while the rest of the city was building a massive network of bridges, tunnels, and roadways to connect the city's various landmasses, Staten Island remained relatively isolated until somewhat recently. For example, the first bridges connecting Staten Island to the rest of the city were built nearly fifty years after the Brooklyn Bridge. As a result, Staten Island remained a mostly wild mixture of forests and marshes, home to salamanders, foxes, egrets, and loads of other wildlife, though not that many people, at least when compared to its present-day density.

Map of the
City of New York
1609

The most notable change to occur on Staten Island—and maybe anywhere in the world, for that matter—happened at Fresh Kills, a location that once boasted streams and tidal marshes but eventually became home to millions of tons of city garbage, four trash mountains so massive they could be seen from space.

The Bronx

The Bronx, the northernmost part of the city and the only borough physically connected to the mainland United States, is bisected by the Bronx River, once known as Aquehung, or "the river of high bluffs," by the Mohegan Tribe native to the area. It was just one of many streams and rivers running through the wooded borough, nearly all of which were chock-full of beavers, as well as countless species of birds and fish. The Thain Family Forest, a small parcel of land that sits just north of the botanical garden, is an indication of how most of the Bronx once looked, a pocket of virgin wilderness in an otherwise urbanized landscape.

Toward this borough's southern and eastern shorelines are about a dozen small harbor islands, including the former Hunters Island, which was eventually combined with 115 acres of sand hauled all the way from the Rockaways to create the crescent-shaped and artificial Orchard Beach.

Queens

Out in Queens, near where the Mets play in Flushing, the area was once covered in marshlands bisected by the Flushing River. The waterway was incredibly rich in biodiversity. Of course, to land developers, it was worthless. At the turn of the nineteenth century, the area was used as a dumping ground for burned garbage, one ash heap so large it was known as Mount Corona. (Lovers of literature will recognize this same "valley of ashes" from *The Great Gatsby*.) That ash and other landfill would eventually get dumped in the nearby wetlands as the area was transformed into parkland, lanes of expressway, and sporting complexes. In total, seven million cubic yards of material were redistributed over the Flushing Meadows. Even the nearby Meadow Lake, the largest lake in New York City, is itself artificial.

At the southern end of Queens, Jamaica Bay is also much changed: once tidal wetlands extending for nearly twenty-five square miles, it now encompasses the John F. Kennedy International Airport and much more. There are three square miles of wetlands reserved as a wildlife refuge at Jamaica Bay today, which is nice and all, but only a shadow of what was originally there.

Brooklyn

In Brooklyn, the Gowanus Canal, now called Lavender Lake due to its polluted appearance, was once known as the Gowanus Creek, a significant tidal inlet serving as an estuary and repository for several nearby streams and marshlands, as well as an ideal habitat for oysters. Today, however, it's a federal Environmental Protection Agency (EPA) Superfund site with a ten-foot layer of sediment on its floor aptly referred to as black mayonnaise. Not surprisingly, there's very little wildlife there now.

The outer edges of Brooklyn's shoreline have also changed, grown, and expanded over the years. Even Coney Island, as its name suggests, was once an island. Today, it's connected to the rest of Brooklyn with landfill.

The Buttermilk Channel, the body of water between Brooklyn and Governors Island, was once walkable at low tide. However, the thousands of new acres of reclaimed land intensified the flow of water over the decades, making such a journey impossible today. Governors Island itself gorged on some of that landfill, swelling to nearly three times its original or "natural" size.

Manhattan

Manhattan, too, is much bigger. The island today is about twenty-two hundred acres larger than it was on that day Hudson arrived in 1609. The landscape is different too. For instance, there once was a large freshwater pond near where City Hall now stands. A primeval forest spread across the northern end of the island in present-day Inwood. Moraine and striations from the glaciers that once carved out New York City's unique archipelago of islands and waterways can still be seen in Central Park. The Lenape people lived on the island then, but so too did bears and wolves.

In those pre-Dutch days, countless rivers and streams crisscrossed the island, including the Minetta Brook, which ran from around the Flatiron Building near Twenty-Third Street and Fifth Avenue, south through present-day Washington Square Park, following the curve of its namesake, Minetta Street, before finally joining the Hudson River near TriBeCa. It was once home to trout, beavers, birds, and more. Today, it's part of the combined sewer system, and its current wildlife inhabitants are mostly rats, cockroaches, and the occasional snail.

Although the Minetta Brook is now invisible, it's by no means gone. Rivers and streams can't be turned off. Rather, they are often the product of topography and weather, joined together to find the path of least resistance. In fact, there are still many vestiges of the stream evident all along its old route: An apartment building on Fifth Avenue near Washington Square Park used to showcase a clear plastic tube of running Minetta water in its lobby. The basement of the NYU Law School Library is routinely flooded with Minetta water as are the basements of many buildings on Minetta Street and the adjacent Minetta Lane. Even the shape of Minetta Street, a kinked elbow along the otherwise rigid grid of Manhattan, is a testament to this forgotten waterway. There, on that one bent street in Greenwich Village, the city contorted its ninety-degree angles to accommodate the now-buried stream.

Steve Duncan is an urban explorer, historian, and expert on Minetta Brook. He has made a name for himself exploring sewers throughout the world. Aboveground, he occasionally leads walking tours through Greenwich Village, where armed with two large orange traffic cones and one mini crowbar, he pops off manhole covers to provide a view of the rushing stream of Minetta water beneath the streets.

"One thing I would love to do is put a few windows into the ground so people can see the water," says Duncan. "I think if they see water flowing they're more inclined to say, 'Ew, why is that stream water all mixed with sewage?'"

Thankfully, there are many New Yorkers like Duncan out there, providing these kinds of views into the wild world of New York City. After all, we are more likely to care for what we are aware of, what we can see.

So with that in mind, let's have a look.

The Natives

The native animals of New York City predate the buildings, the subways, even those early Dutch who called the city New Amsterdam. Many of these hardy critters stuck it out during the worst years of New York's dark ages. Today, some are too numerous and some are too few, but these animals have persisted, successfully making the adjustment to city living. They are the original New Yorkers.

Latin Name	Collective Noun
Mammut americanum	a herd of mastodons

Mastodons

New York City has a notoriously hard time holding on to its past. But it's not just classic architecture and cool dive bars that disappear without a trace. Fossils are easily lost beneath the city streets too. That's why it might be surprising to learn that thousands of years ago, prehistoric animals roamed this area, including the mighty mastodon, an ancient animal with an outsize physical presence to match its huge historical significance.

Mastodons were shorter than their wooly mammoth cousins, standing at about ten feet tall. They lived in North America, typically near the coasts. They existed up until about ten thousand years ago, toward the end of the Pleistocene Epoch, at which point their species died off completely.

The first mastodon fossil ever discovered anywhere in the world was found in 1705 by a farmer in Claverack, New York, a small town about a hundred miles north of Manhattan. It was a tooth fossil, about the size of a fist. It ended up being a pretty important find.

The word *mastodon* is Latin for "nipple tooth," and it's these uniquely shaped teeth of theirs that distinguish mastodons from their cousins, the woolly mammoth and the modern elephant.

At the time the mastodon tooth was found upstate, some believed it belonged to one of the giants mentioned in the book of Genesis, while others believed it was the damaged tooth of an elephant that had washed ashore to North America during the great flood of Noah's Ark.

Nobody could have guessed this fossil was a mastodon, because nobody on Earth knew what a mastodon was in 1705. We have a greater understanding of prehistoric animals and extinction now, but that was not always the case, even just three hundred years ago. The concepts of fossils, extinction, or even an Earth more than a few thousand years old were unfamiliar to even the world's brightest minds. For example, George Washington, who died in 1799, would have had no way of knowing what a dinosaur was.

As far as humanity was concerned, God's chain of creation remained unbroken, and nothing he created could possibly have gone extinct. That was the thinking, of course, until the discovery of this tooth and the ensuing realization that it could not have belonged to any elephant, not even one of Noah's. In many ways, paleontology and humanity's understanding of its own place in geological time can trace its roots to the mastodon and this tooth found in upstate New York.

According to Carl Mehling of the American Museum of Natural History, New York City is home to at least a dozen mastodon fossil sites. But there's a catch. "Almost none of them exist

anymore," says Mehling. "They were found way before there was a proper repository like us. There are just records of them being found but no specimens."

One of the more famous discoveries—one that did eventually make its way to the museum—was found in the Inwood neighborhood of Manhattan in 1925. Up on Seaman Avenue, funnily enough, not far from where it intersects with Cumming Street, a new apartment building was under construction. As the crew hollowed out the grounds for the foundation, one of the workers, Mangillo Domenico, noticed a strange discovery. "Bones!" he yelled to his coworkers. Specifically, he had found the lower jawbone and teeth of a young mastodon.

"They must be elephant bones," said Ambrose Conforti, Domenico's boss.

Later that day, Dr. C. C. Mook from the American Museum of Natural History was dispatched uptown to collect the bones for preservation. But before he arrived on the scene, Inwood locals had made off with the majority of the specimen. One story, reported in the *Sun* on March 25, 1925, recounts a construction worker showing the fossils to a local milkman only to have that milkman run away with the bones himself. The *New York Times* corroborated this account and even managed to get a quote from the sticky-fingered milkman in question. "I want this for Hazel," he said. "It'll be a corking thing for the whatnot."

By the time Dr. Mook arrived on the scene, only three teeth were left for him to bring to the museum. But then *two* of those remaining three teeth were pickpocketed from him as he made his way from the construction site back to his

car only a few blocks away. All told, thirteen of the fourteen teeth found that day were pilfered by locals.

The *New York Times* article from the following day called keeping such artifacts "atrocious luck." Perhaps hoping to avoid bad fortune, people eventually sent most of the Inwood bones to the museum.

Despite the relatively small amount of fossilized evidence, Mehling is quick to point out that many mastodons lived and died in New York City. "We have every indication that mastodons were all over the Northeast," says Mehling. "The fossils in New York City aren't some rogues who made it here. These animals were New Yorkers. There's a damn good chance there were mammoths here—and giant ground sloths and native horses too." The problem is that finding a mastodon fossil—or any fossil, for that matter—in the city is, as Mehling puts it, "insanely hard" because fossils are typically found in sedimentary rock, such as shale, limestone, and sandstone, but New York City's foundation is mostly metamorphic rock, which produces too much heat and pressure for anything to leave an imprint or a record.

Geologically speaking, New York City is designed to carry on as though the past never existed. Culturally speaking, this rings true too. The city is famously unsentimental. Penn Station, Mars Bar, Ebbets Field—all gone without a trace. Mehling chalks it up to luck that any fossils exist here at all. What makes the Inwood specimen so unique is that it essentially died in the perfect place, where conditions were just right for preservation, and where thousands of years later, New York City was given a rare glimpse into its ancient history.

Latin Name	Collective Noun
Nycticorax nycticorax	A siege of herons

Black-Crowned Night Herons

Some of New York City's most exclusive real estate is strictly for the birds. Specifically, the network of abandoned harbor islands that is home to countless shorebirds, including the oddly regal black-crowned night heron. These long-legged wading birds prefer to avoid people, which admittedly is a tall order in New York. Luckily for the birds, however, this densely populated city still has a few quiet places free from human impact.

North Brother Island, maybe the best known of these harbor islands, sits about a quarter mile from the Bronx shoreline in the East River, not far from Rikers Island and South Brother Island. Before it was abandoned by New Yorkers in the 1960s, it housed the Riverside Hospital for Communicable Diseases, a quarantine hospital for typhoid, a disease fueled in large part by poor environmental practices that tainted the food supply. The most notable of the island's quarantined residents was Typhoid Mary Mallon, the infamous Irish cook who was accused of infecting countless New Yorkers despite never showing any symptoms herself.

With humans gone, wild plant growth exploded across North Brother Island, enveloping the entire twenty acres. In some spots on the island, the vegetation is so thick that it's literally pulling down the neglected buildings and infrastructure.

The whole island is quite picturesque, as though human civilization was paused and never restarted. It's like a test model, a life-size diorama, of what the rest of New York City would look like if humans just went away.

In other words, North Brother Island is extremely cool. It's also technically off limits, which only makes it more appealing. Not surprisingly, it's a popular destination for intrepid (and scofflaw) photographers, artists, and other adventurous people interested in experiencing these unique urban ruins before it all turns to rubble. Presumably, those explorers travel there by kayak from the Bronx shoreline, and most likely they are doing so without permission.

The Parks Department manages North Brother Island, and makes few, if any, exceptions

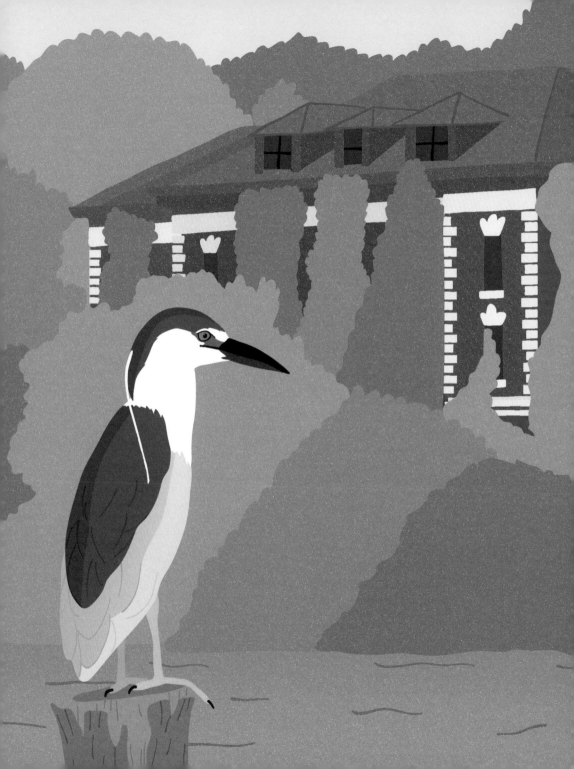

for visitors, even for those, say, writing a book about the wildlife of New York City. With buildings that are actively shedding bricks, the island poses a certain danger. But the department is also keenly interested in keeping the area untouched for bird species like the black-crowned night heron, which are of conservation concern in New York State.

Physically speaking, black-crowned night herons are odd-looking little critters. They are squat when standing yet slender when in flight. As their name suggests, they have dark plumage up top. They also have stop-light red eyes and taxicab yellow feet. They look a little out of place in New York City (though they probably look a little bit out of place almost everywhere).

"It's our responsibility as New Yorkers to ensure that this population has this place to reproduce," says Dr. Susan Elbin, the New York City Audubon Society's director of conservation and science, who works with the Parks Department to survey these birds. By her estimates, more than 80 percent of all black-crowned night herons in the state can be found in New York City. They have been spotted in Harlem, Brooklyn, and many other places in the city. Their preference, however, is harbor islands with natural shallow shorelines, which is something of a rarity in overdeveloped New York City.

The birds also don't want people around them.

"The nature of water birds is that if you disturb them, like if a person goes on the island at a certain sensitive period of time when they're setting up the nests, they'll just go somewhere else. And then they won't be here in New York City anymore," says Elbin. "So we're very careful.

People are not allowed on those islands, especially from March to August."

The black-crowned night herons no longer nest on North Brother Island, but they do breed on nearby South Brother Island. It's not clear why they swapped islands. They still "hang out" on North Brother Island, as well as on the other islands throughout New York Harbor that make up the network of open spaces perfect for their needs. These islands—nearly twenty of them—are also important to countless species of migrating birds. "Taking that landscape view flying across the city, it's a little green place to stop when you're moving along the Atlantic Flyway," says Kristy King, natural areas restoration director for the Parks Department.

For a town so obsessed with making the most of every square inch, it's incredible that there could be so much land devoted to a species of bird most people have probably never heard of before, and, given the restrictions on visiting their habitats, won't be observing up close anytime soon. "I would love to see the city invest so people could see what's happening on these islands. Because it's not fair," admits Elbin. "There doesn't need to be Disneyland there. Just put some webcams up so people can see what's going on."

However, North Brother Island is not here to delight birdwatchers or other curious New Yorkers. Instead, it houses the ruins of a typhoid hospital that needed to be built because New York City polluted its environment so recklessly. These dilapidated relics are the physical proof of what happens when an ecosystem is mistreated, and perhaps the best possible argument for why these islands ought to be left for the birds.

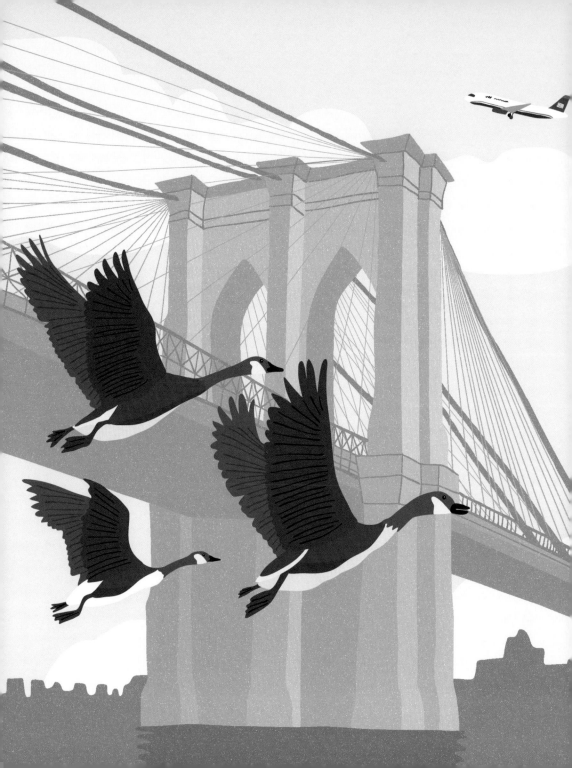

Geese

On the afternoon of January 15, 2009, US Airways Flight 1549 departed LaGuardia Airport in Queens destined for Charlotte, North Carolina. Only moments after take-off, the aircraft found itself in crisis, having collided with a flock of Canada geese, some of which were sucked into the plane's engines. A few moments later, Captain Chelsey "Sully" Sullenberger brought the aircraft safely down in what one National Transportation Safety Board official called "the most successful ditching in aviation history." Of course, most people know this event by its more commonly referred-to name, the Miracle on the Hudson.

Remarkably, all 155 human passengers aboard the flight survived. Captain Sully was given the Tom Hanks treatment and rightfully became synonymous with grace under pressure.

However, the other species involved in the incident, the Canada goose, has not fared as well.

In the intervening years since that fateful January morning, nearly seventy thousand birds, many of which were geese, were euthanized by the US Department of Agriculture (USDA) at the metro area's three major airports.

The stewards of Governors Island, one of the city's newest open spaces, have taken a more humane approach (or, technically, more of a canine approach) to the influx of geese. Max, a border collie, is tasked with chasing them away. He is described by the Governors Island website as having a type A personality, meaning he loves to work. Like a lot of dogs, and many New Yorkers for that matter, he maybe even *needs* to work in order to be happy. Max is without a doubt a very good boy, though some argue this whole approach has its flaws.

"I think it's pointless," says David Karopkin, founder of GooseWatch NYC, an organization that advocates for compassionate and tolerant coexistence with urban wildlife. "I think scaring the geese from Governors Island to Red Hook doesn't really accomplish anything in terms of aviation safety."

Karopkin began GooseWatch NYC in 2011. He was born and raised in Brooklyn, not far from Prospect Park. Growing up, he had very little exposure to wildlife, but things changed in 2009, when the city began rounding up Canada geese for slaughter. It was the first year geese had been targeted outside of airport properties, like in city parks, and by no small coincidence, this first roundup happened only months after those other geese tried to kill Captain Sully.

A year later, in 2010, 368 geese were condemned in Prospect Park alone. The handful of geese in this park that survived until 2011 had their eggs "oiled" as a means of population control. Rather than removing the eggs from the nest, the eggs are coated in oil at a certain stage to make the geese believe the eggs are viable when they are not. When done correctly, oiling has been shown to stabilize, even reduce, population sizes (it's certainly more effective than the dogs), though it is by no means foolproof.

In the spring of 2011, an oiled nest somehow produced healthy offspring that were referred to as the "miracle goslings." They were the first baby geese Karopkin had ever seen in his life. "I fell in love," he says. "And I felt like over my dead body these geese are going to be killed by the USDA this year." Karopkin has a point about baby geese—they are adorable. They are fluffier, softer, and presumably much sweeter than the adult geese they will grow up to be.

What's more, according to Karopkin, the geese involved in the Miracle on the Hudson were not even New York City resident geese but rather migratory birds (aka tourists). He swears there is even DNA proof that the Miracle on the Hudson involved birds that flew at an altitude

that resident geese would never reach at that time of year. "If you had killed every single resident Canada goose in New York City in 2008, you would not have prevented the Miracle on the Hudson," Karopkin said.

In the years since, Karopkin has been adamant about defending local geese. He leaned on his legal background and emailed his friends and neighbors, and before long, GooseWatch NYC was off the ground. He initially scheduled shifts of volunteer sentries to keep an eye on the Prospect Park geese and their goslings, and he continues to pepper the city and the USDA with Freedom of Information Act requests to ensure the geese are treated fairly. He admits that parks full of goose poop, often left by resident geese, is less than ideal. But while Canada geese may be a bit gross, and perhaps even a nuisance, certainly extermination is not the only solution. "I have upstairs neighbors. They make a lot of noise. They piss me off," he says. "But I don't go upstairs and kill them. I coexist."

According to Karopkin, geese should be extended similar courtesies. But until that day, he will be out there passionately defending the sullied reputations of these big native birds. "We all have a right to exist," he says. "We all have a right to be here."

Latin Name	Collective Noun
Odocoileus virginianus	a herd of deer

Deer

There's a bit of an argument over how many white-tailed deer there are in Staten Island. A 2014 estimate showed 793 deer on the island, which shocked officials, though Dr. Anthony DeNicola, founder of White Buffalo Inc., a nonprofit organization focused on the conservation of native species and ecosystems, says the true number is well over 2,000. Either way, almost everyone agrees there are too many.

These Staten Island deer are not confined to isolated wooded areas either. On the contrary, they dash across highway traffic, torment local gardeners, and generally throw the Staten Island ecosystem into disarray.

In 2017, one particularly destructive deer barged its way into the Phase Fashions clothing store in the New Dorp neighborhood of Staten Island, smashing against mirrors and leaving blood all over the place, all during business hours. It's a problem.

DeNicola and his team at White Buffalo have been contracted by the New York City Parks Department Wildlife Unit to deal with the issue. Throughout most of the fall and winter months, a nightly nonlethal "hunt" of male deer occurs on Staten Island. The bucks are hit with trackable tranquilizer darts and given a field vasectomy once the sedative takes hold.

DeNicola has about three hundred kernel-corn bait sites scattered throughout the island to lure the bucks within darting range, which he says is between five and twenty-five yards. But often he and his team can work remotely from a vehicle, essentially performing drive-by dartings.

That's how many deer there are in Staten Island: DeNicola doesn't even need to get out of his car to dart them.

Once snipped, the bucks are then given a numbered cattle ear tag to indicate they have already been genetically neutralized, a long-lasting pain medication and antibiotic, and an upper to reverse the anesthesia. All told, it's a thirty-minute process, at the end of which the bucks are free to go on their wild way with only the ability to make more little baby deer taken from them. On a good night, White Buffalo can take about a dozen bucks out of the mating pool.

The Parks Department believes in this solution, even if the timeline leaves some locals anxious for faster results. Richard Simon, director of the Wildlife Unit, is aware of the impatience but maintains that while a hunt provides a short-term solution, it will not completely solve the

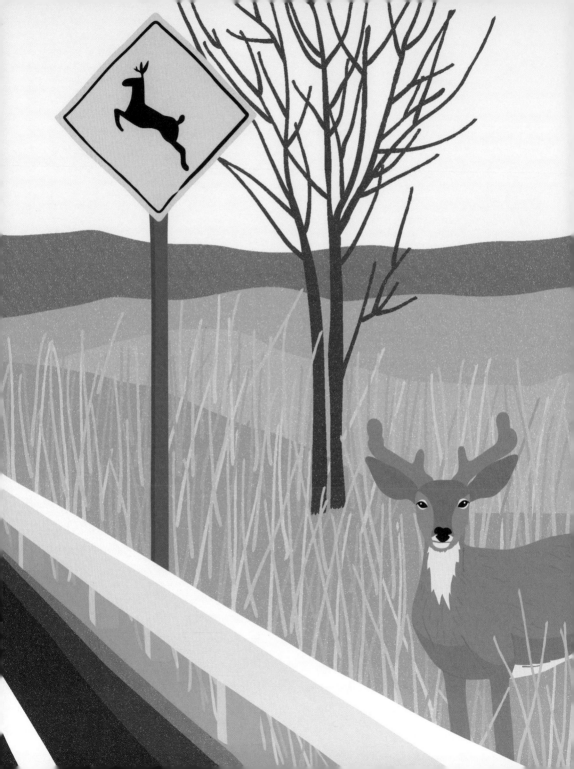

problem. "Front-loading this, taking care of the bulk of it now, it's going to be expensive, but costs will begin to drop down as there are fewer and fewer deer left to sterilize," he said.

But cost-benefit analyses over the long term don't play well in headlines, and the sterilization program is getting killed in the press. The price tag doesn't help: the city has spent over three million dollars on deer vasectomies in three years. That certainly sounds like a ludicrous

spaces, especially in Staten Island. Not surprisingly, deer favor those kinds of places too. People love wildlife in the abstract, but the reality of a two-hundred-pound whitetail grazing dangerously close to the high-speed traffic on the Staten Island Expressway or even running amok in a neighborhood dress shop is inconvenient and sometimes deadly.

New York City's deer management method may be unconventional and expensive, but

66

Having too many deer is the price we paid for removing predators to make places safer for humans to live.

99

amount of money, but there is nothing with which to compare it—New York is the only municipality trying this nonlethal approach.

Deer populations require human intervention, regardless of how it is done. Nature intended for bears, wolves, and mountain lions to manage the number of deer, but people drove those animals away. Having too many deer is the price we paid for removing predators to make places safer for humans to live.

Additionally, the city has spent decades rightly greening itself with parkland and wild

it's probably the only option. A hunt with live ammunition anywhere in the city, even in somewhat suburban Staten Island, is a nonstarter, a logistical impossibility. Plus, according to DeNicola, killing the deer would incur its own kind of backlash. "Staten Islanders are a unique bunch," he says. "They're blue-collar people, but they love their deer."

And so DeNicola and his deer hunters are out there working, slowly but humanely. They are nipping the problem in the bud, one buck at a time.

Latin Name	Collective Noun
Carcharodon carcharias	a shiver of sharks

Sharks

According to a popular quip floating around the internet, it is ten times more likely for a New Yorker to get bitten by another New Yorker than it is for anyone anywhere in the world to get bitten by a shark. This "statistic" illustrates how rare shark bites are while simultaneously nodding to New York's reputation as a tough town where people apparently bite one another all the time.

What is probably most surprising, however, is that there are a fair number of sharks in the city's surrounding waters and that these predators have always been there. According to John Kieran's 1959 book, *A Natural History of New York City*, "Everybody is interested in sharks, which are frequent intruders in New York City waters and often cause excitement among bathers at Coney Island or along the Rockaway beaches." Paul Sieswerda, former curator of the New York Aquarium and current president of the wildlife conservancy group Gotham Whale, believes that there are still many sharks in New York City. The New York Bight, the body of water that runs from the mouth of New York Harbor along the southern shore of Long Island, is an incredibly important area. "This is a nursery for great whites," says Sieswerda.

According to another leading expert on sharks in the city, Dr. Craig O'Connell of the O'Seas Conservation Foundation, they can be found even closer to the city's shore. "I have personally captured sharks right in New York Harbor," he says. "I have heard reports of common thresher sharks and baby great whites being captured as well . . . I am confident that they do make an appearance under the Verrazzano Bridge more often than we think."

O'Connell is quick to point out that sharks pose very little risk to New Yorkers: they are much more likely to spend their energy hunting harbor seals. "You must think of it as a cost-benefit type of situation. They expend enormous amounts of energy just doing their everyday tasks, including swimming, chasing prey, digesting prey, escaping predators. Therefore, feeding on something that may not be energetically beneficial to these sharks just doesn't make sense," he says. On the contrary, these large apex predators provide a great benefit to the local ecosystem.

That's not to say the waters around New York City aren't dangerous. They are. There's a major threat lurking beneath the waves that should strike fear in the hearts of any water-bathing New Yorker, but it's not the sharks. According to a 2018 study in the *International Journal of Epidemiology*, the risk in the water is illness due to untreated human waste. In a way, that internet joke about New Yorkers getting hurt by other New Yorkers was correct—it just had the wrong end of the body.

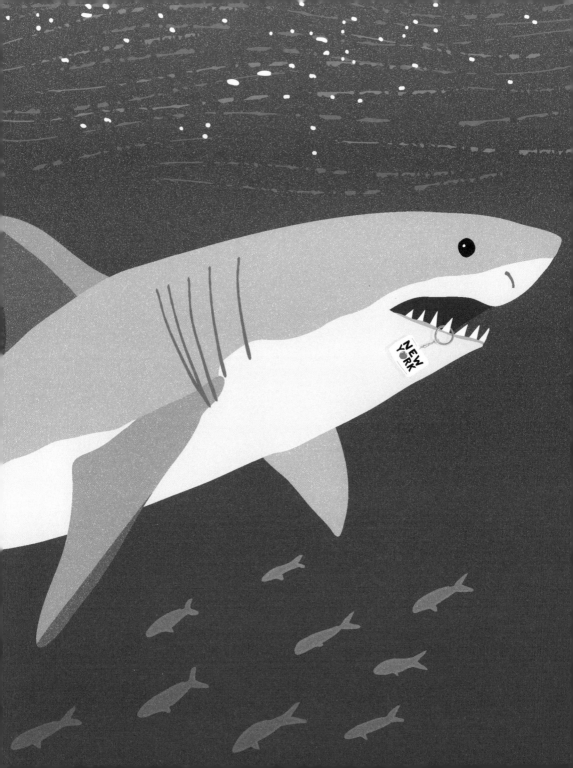

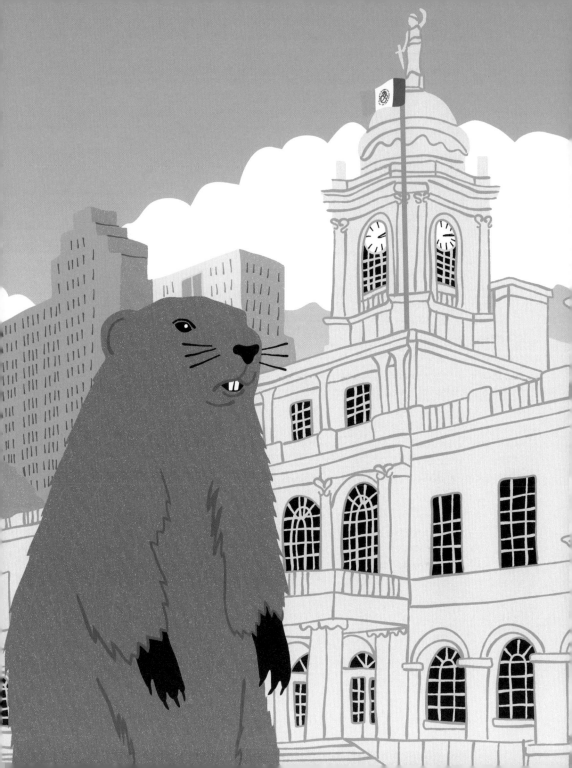

Latin Name	Collective Noun
Marmota monax	a repetition of groundhogs

Groundhogs

Groundhogs are large members of the rodent family. Some call them woodchucks, Canadian marmots, or even whistlepigs. For whatever reason, they are also known as meteorologists, rising from their burrows every February 2, usually with great fanfare, to cast their prediction on the commencement of spring, often incorrectly.

The most famous weather-forecasting groundhog, of course, is Phil from Punxsutawney, Pennsylvania. A movie was made about him. But New York City has its own forecasting groundhog, Chuck from Staten Island, who is famous in his own right. His story is no romantic comedy, however, but rather a tale of political intrigue told beneath the shadowy clouds of murder.

Now, typically, Groundhog Day is the type of ceremony most elected officials find banal but obligatory, in the same category as cutting a ribbon with oversize scissors, kissing random babies, and giving out keys to the city. From time to time, even the mayor of New York must do such trivial things, and included among His Honor's duties is the annual visit to the Staten Island Zoo to see if Chuck casts his shadow.

Mayor Bill de Blasio made his first official trip to see the Staten Island groundhog in early February 2014. At the time, he had been in office

barely a month, though the fallout from that fateful visit would last much longer.

Reports differ on what exactly happened that morning. Some say the groundhog squirmed. Others say His Honor fumbled the hand-off. But regardless of how it happened, the beloved critter fell to the ground, injured. It was a blunder, all right, but the story was about to get much weirder.

For starters, the fall was much worse than had been initially reported, and, sadly, the groundhog died five days after the event due to internal injuries. But for whatever reason, the Staten Island Zoo didn't report the fatality for months and instead kept the public in the dark about the groundhog's demise.

Stranger still, it was then revealed that it wasn't even Staten Island Chuck who died that morning but rather Charlotte, his granddaughter. Chuck was apparently a bit of a jerk who famously bit Mayor Michael Bloomberg at the 2009 Groundhog Day ceremony, so the zoo didn't want to risk another toothy situation with the new mayor. They subbed in Charlotte to play the part—it was a controversial role and one that would eventually cost her her life.

Being a party to a cherished groundhog's death wouldn't help any mayor's popularity, and it was no surprise that de Blasio didn't come out unscathed. Making matters worse for the mayor,

Staten Island is a reliably Republican enclave that was already lukewarm on de Blasio, a Democrat. Having groundhog blood on his hands certainly did not help.

Critics might say that only Bill de Blasio could have screwed up something so simple as tall—a groundhog falling from that height might have stood a better chance of surviving.

Eventually, though, the story went cold. It's New York City, after all, so other scandals inevitably popped up to grab the public's attention. That was until two years later, in July 2016, when

> **"**
>
> **New York City has its own forecasting groundhog, Chuck from Staten Island, who is famous in his own right. His story is no romantic comedy, however, but rather a tale of political intrigue told beneath the shadowy clouds of murder.**
>
> **"**

a Groundhog Day ceremony. And this might be half true, though maybe not in the way detractors contend. Mayor de Blasio is six feet, five inches tall, meaning any groundhog who fell from His Honor's arms would be doing so from an above-average height. By way of contrast, Mayor Fiorello LaGuardia was only five feet, two inches a large, scruffy rodent was seen scurrying around City Hall Park just outside the mayor's office. The Parks Department refused to confirm the sighting, but those who saw the animal or the subsequent photographs had little doubt: it was a groundhog all right. Some say it was looking for food or a place to live. But just maybe it was seeking revenge.

Latin Name	Collective Noun
Buteo jamaicensis	a kettle of hawks

Hawks

By the numbers, Pale Male is easily the most famous bird in New York City. This red-tailed hawk, who nests on a Fifth Avenue penthouse ledge overlooking Central Park, has been the subject of three books, two movies, and one celebrity-backed protest. He is also a prodigious breeder, having sired dozens of offspring.

Hawks have not always lived in the city year-round. In his 1959 book, *A Natural History of New York City*, John Kieran noted how rare these birds once were: "The redtail is a regular winter resident in small numbers. Unquestionably only a scant few now find nesting sites within the city limits." Pollution and general disregard for nature played a big part in keeping these raptors at bay. However, the hawks began to appear more consistently in the 1990s, and today there are about thirty nesting pairs throughout the five boroughs.

Pale Male was among the first of these full-time urban hawks. He was initially noticed around Central Park in 1991, and his name came from the distinctive white feathers around his face. Quickly, he became something of a local celebrity. The first Pale Male book, *Red Tails in Love* by Marie Winn, was published in 1998. A few years later, in 2002, the first movie in his honor, *Pale Male*, was released. It depicts the locals, including Winn, who would flock to watch the raptor's nest from across the street at the model boat pond in Central Park every morning. It's a sweet story.

Conflict came a few years later in 2004, when the co-op board members in charge of 927 Fifth Avenue, Pale Male's building, decided to evict the love nest, citing safety concerns—though the building's residents not appreciating the many bird-watching binoculars pointing at their windows every day probably also had something to do with it.

The eviction of Pale Male and Lola, his mate at the time, stirred something in local New Yorkers. The bird-watchers from the model boat pond in Central Park transformed into sidewalk protesters, picketing outside the fancy apartment building with signs that read "Honk for the Hawks."

These protests were a turning point for the New York City birding scene. Mary Tyler Moore, who lived in the building, would eventually throw her hat in the ring to support the birds, often joining protesters on the sidewalk. In the end, the hawks were allowed to retain their nest, which is still there today, albeit with some structural modifications.

Incredibly, Pale Male is also still there. At the time of this writing, he is at least twenty-eight years old. For reference, a wild red-tailed hawk typically lives between ten and fifteen years. Gabriel Willow, an educator and guide with the New York City Audubon Society, believes Pale Male's choice of nesting spot may have something to do with his longevity. "Here were a pair of hawks that were willing to experiment. They tried nesting on a building in an urban setting and it was a tremendously successful strategy because there was this empty niche," he says. "What we're seeing is behavioral evolution . . . that's created this radical shift, where in the span of a human generation, you now have hawks fairly ubiquitous in the city."

Pale Male's mates have been less fortunate. His first mate, appropriately named First Love, would eventually be found dead on the roof of the Metropolitan Museum of Art after eating a poisoned rat. His second wife, Chocolate, was killed on the New Jersey Turnpike. His third wife, Blue, disappeared around the September 11 attacks in 2001. He was with Lola, his fourth wife, during the eviction crisis, and most recently, he has been nesting with his appropriately named eighth wife, Octavia.

According to Willow, the process of "remarrying" can take as little time as twenty-four hours (though he really prefers to avoid anthropomorphizing and using human terms like *marriage* or *wives* to describe Pale Male or any animal).

Still, it's hard to blame New Yorkers for seeing themselves, at least an aspirational version of themselves, in Pale Male. Here is a high-flying killer who rebounds immediately after heartbreak, all while paying nothing in rent for an incredible view of Central Park. It's not surprising New Yorkers want to be like Pale Male. It would be more surprising to find a New Yorker who *didn't* want to be like him. And, says Willow, "anything that gets people more involved with nature and conservation is a boon. If we can look at these major metropolises and find there is space for wildlife and what steps can be taken to make it more conducive to wildlife surviving, there are lessons that can be taken from that. When we examine what benefits humanity and what benefits wildlife, nine times out of ten they're the same thing."

There certainly is a lesson to be learned here. Pale Male and his ilk exhibited adaptive survival techniques and as a result are thriving in unlikely circumstances. Humans would be smart to take note of what worked for these hawks and apply some of those adaptability lessons to ourselves before global warming and climate change present us with an eviction crisis of our own.

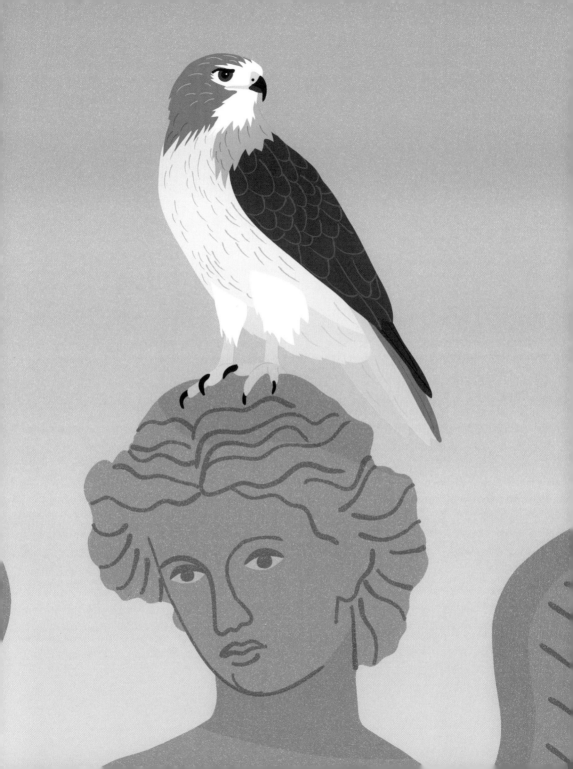

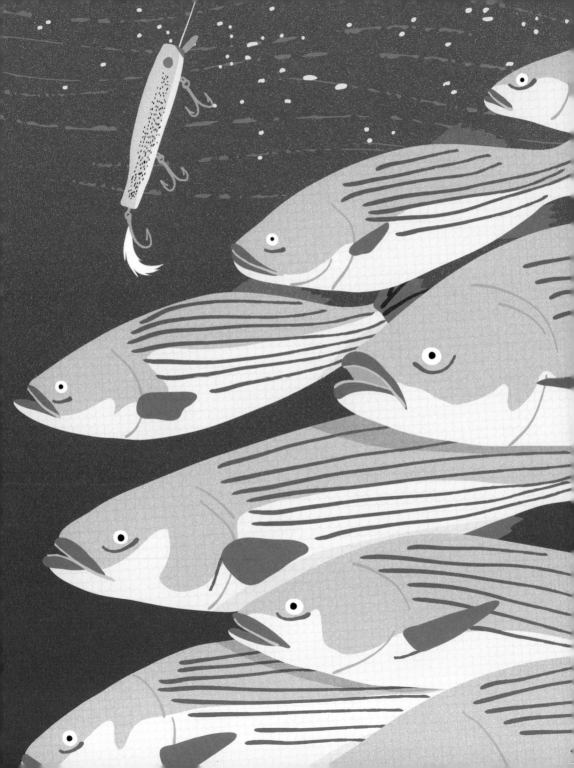

Latin Name	Collective Noun
Morone saxatilis	a shoal of striped bass

Striped Bass

A massive migration occurs twice a year just below the surface of New York Harbor: the running of the striped bass. Like clockwork, these fish ditch the Atlantic Ocean en masse, race through the Verrazzano Narrows, past the Statue of Liberty, and continue fifty miles up the Hudson River to Newburgh, New York, before returning to the ocean.

"The striped bass is the harbor's symbol, a pin-striped tough guy," writes John Waldman in his book, *Heartbeats in the Muck*. Waldman is a professor of biology at Queens College and an expert on New York Harbor. Hundreds of thousands of fish make this trip through New York City twice a year. If there were a transparent view of the river, Waldman writes, "the northward parade of fish would be staggering."

An extraordinary element of this journey is that it requires an anadromous species of fish, one able to survive both the salt water of the Atlantic Ocean where the journey begins, as well as the fresh water upstream where it climaxes.

And, boy, does it climax. Striped bass swim all this way—roughly a hundred miles—to spawn, which is just a polite way of saying ejaculate. It's a spectacular display of a species traveling great distances propelled by a biological imperative. It's also maybe something to keep in mind before swimming in the Hudson River anywhere near Newburgh.

As fun as all this sounds, it hasn't always been a honeymoon for the striped bass. The years between the 1940s and the 1970s were rough on them, as they were for most species. This period can be described as the low point of ecological neglect in the United States, the environmental dark ages. Locally, the Hudson River was being polluted by General Electric, who dumped around thirty pounds a day of the cancer-causing polychlorinated biphenyls (PCBs) into the water. *Sports Illustrated*, writing about the issue in 1975, called it "the largest nonaccidental release of these poisons anywhere in the US and possibly the world." This malfeasance had a silver lining in that it basically ushered in the Clean Water Act, Environmental Protection Agency, and other regulatory safeguards. However, the Hudson River is still very toxic and tragically will be for a long time.

One of the downstream effects of all this pollution has been its introduction into the food chain. Typically, PCBs are first absorbed by phyto-plankton, which are eaten by little fish, which in turn are eaten by the bigger ones, such as the striped bass. In time, even these tough fish were found to have a potentially unsafe amount of PCBs in their fatty tissue. This contamination,

while definitely not awesome, did effectively reduce their allowable catch, which in a roundabout way has been beneficial for their population numbers.

So, though striped bass stocks are stable now, individually they are by no means completely safe to eat. The New York State Health Department suggests that adults limit striped bass meals to one per month. They say children under the age of fifteen should abstain altogether, as should any woman who is trying to get pregnant.

Nonetheless, some New Yorkers have decided to live dangerously. After all, it's hard to argue with free catch-it-yourself protein. PCBs are dangerous, but they can't be worse than malnourishment. As such, many locals flout the health recommendations and instead cast their fate, and their lures, into the water.

Tony DiLernia is one of these brave people. He has been fishing in New York City waters his whole life. In 1994, he started Rocket Charter fishing trips. His boat, *The Rocket*, docks at East Twenty-Third Street in Manhattan. For five days a week, six months a year, DiLernia takes amateur anglers, who otherwise work as bond traders and dentists, out to fish local stripers, usually to their disbelief.

"First-timers are always skeptical once they get on the boat," says DiLernia. "By the end of the night, they're always like, 'Holy shit! Look what we caught.'"

It's unbelievable, all right, especially considering *where* the fish are caught: it's basically Midtown. Sometimes DiLernia may go as far as the Statue of Liberty to look for striped bass, but often enough, *The Rocket* is moored right in the shadow of the United Nations, only a stone's throw from the FDR Drive, pulling up more striped bass than anyone can believe.

Striped bass, of course, are not the only fish swimming in New York Harbor. There are also tomcod, winter flounder, and bluefish, among others. However, these other species have all seen their numbers decline in recent years, and the Atlantic mackerel, DiLernia says, has been gone since 1982. Even people who don't fish and may not be able to tell one species from another can see that New York Harbor is still an ecosystem in peril. Pollution is just one part of the problem. Increasing water temperatures and shifting levels of ocean acidity also play a part.

Still, the harbor has shown some signs of turning around. Some say it is the cleanest it's been in a century, which may say less about its improvement and more about how awful the water once was. Regardless, DiLernia says he can see a difference in water clarity. If New Yorkers can help protect the environmental regulations already in place, like DiLernia and other fishermen suggest, the city may soon see an even cleaner harbor still.

Latin Name	Collective Noun
Malaclemys terrapin	a bale of turtles

Turtles

Turtle soup was once one of the most popular dishes in New York City. It was served to General Washington and his troops at their famous farewell banquet at Fraunces Tavern in 1783. According to Leslie Day's *Field Guide of the Natural World of New York City*, turtle soup remained a culinary mainstay until the 1930s when the supply basically ran out. Though things have since improved for the shell-bound critters, it's still a tough town for turtles.

The endangered sea turtles that visit the area have to navigate a host of threats, as must the smaller turtles who live here full-time. Luckily for these animals, a band of dedicated human advocates are working tirelessly to keep them afloat.

"New York City can be surprising sometimes. It's this hidden gem of wildlife. I think there's a lot more in the water than people realize," says Maxine Montello, the rescue program director for the New York Marine Rescue Center, which helps injured marine animals in and around the city get back in the water as soon as possible. Concerned citizens can call in lost or injured animals to the rescue center's stranding hotline. From there, a rapid-response team is deployed to investigate the scene. There's even an "ambulance" (which is really just a fancy truck) with generators that allow one team member to work while another is driving.

A lot of their patients are sea turtles, of which there are four types known to frequent New York City: loggerhead, leatherback, Kemp's ridley, and the green sea turtle. They are all designated as either endangered or vulnerable species. Montello sees them primarily in the winter months, when these cold-blooded sea turtles are sensitive to sudden drops in water temperature. The technical term for what happens to them is *cold stunning*, and it is pretty much just what it sounds like: paralysis brought on by low temperatures. Sea turtles can't function below 55 degrees Fahrenheit. Sudden cold water renders them completely motionless and more than a little bit vulnerable. Montello instructs her volunteers to be on the lookout for listless turtle shells floating out on the water or stranded on the beach.

Sadly, this isn't the only local threat to sea turtles. Fishing lines, boat strikes, and ingested pollution (namely from submerged balloons and plastic bags that look like jellyfish) make it dangerous out there for these turtle tourists. And it's not much better for the ones that live here

year-round: these smaller turtles typically live in brackish waters like the Jamaica Bay Wildlife Refuge in Queens.

Honestly, it's great that New York City has a wildlife refuge, even if it is a shadow of what it once was, with an international airport on its eastern shore and subway tracks running through the middle of it. Yes, it is surrounded by former landfills, including one that erupted some time in the 1950s and was subsequently polluted with decades' worth of toxic waste. But, all *that* aside, it's still a relatively wild space in an otherwise highly urbanized area.

Dr. Russell Burke, a biology professor at Hofstra University, has been studying diamondback terrapins in Jamaica Bay for over two decades, specifically the terrapins of Rulers Bar, one of the bay's larger central islands. He has concerns about these terrapins and their local ecosystem. As the sea levels rise due to greenhouse gas emissions, the salt marshes decrease in size, and so do the terrapin populations. According to Burke, there are efforts under way to restore the bay's salt marshes, which helps. His fear, however, is that the declines are happening faster than the restoration. Like most experts, he sees a need for reducing greenhouse gases too.

Another unexpected and emerging threat to the Jamaica Bay terrapins is the raccoon. Though new to Jamaica Bay, the raccoons have quickly adjusted their diet to take advantage of nesting turtles. According to Burke, these newcomer raccoons may be eating up to 95 percent of the terrapin eggs on Rulers Bar. This is also a manmade issue: most of the raccoons in Jamaica Bay were "dumped" there when they became too much of a nuisance to people elsewhere in the city. More than likely, these raccoons got too close to people's habitats, apartments, or garages, and had to go.

The interspecies dynamic presents an ethical gray area: Do we support the native raccoons, which are plentiful yet annoying, or the equally native, yet quite vulnerable, diamondback terrapins? Ultimately, it wouldn't be right to choose one animal over the other. But given the steady flow of pollution and diminishing available space for wild habitats, it's pretty clear which species is most to blame here.

Nonetheless, Dr. Burke and his volunteers can be seen on Rulers Bar surveying terrapin diamondback populations several weekends a year. If the volunteers are lucky, they will find a pregnant terrapin who has not yet laid her eggs. If so, she will be whisked away in an orange bucket to give birth somewhere safe. This measure not only protects the mother terrapin, but her entire species too.

Latin Name	Collective Noun
Procyon lotor	a gaze of raccoons

Raccoons

Most animals are not yet equipped to live in cities. It's understandable: urban ecosystems have not been around long enough for most critters to adapt. That's the thing about evolution—it takes a while. Raccoons, however, have made the adjustment and as a result are thriving in places like New York City.

"City dwellers take many forms," says the website for WildlifeNYC, a campaign launched by the New York City Parks Department Wildlife Unit to increase public awareness of urban animals. Staff can't say for sure exactly how many raccoons there are in the five boroughs, but one estimate places the number in the tens of thousands. "We don't have an actual number," says Richard Simon, director of the Wildlife Unit. "But we see them in lots of places. They are not limited to parks. We recently had someone tell us they had a raccoon living on a scaffolding."

Raccoons are incredibly smart and very wily. They will set up a den anywhere that is semi-secluded and near a reliable food source and will gladly manage the contents of your trash bins if they find access to them through a hole in your garage.

Simon warns against intentionally inviting raccoons into your home by feeding them or, worse, trying to adopt them as pets. Feeding wildlife is generally a bad idea: it's not good for the animals and can be potentially dangerous for the human. And aside from that, these chubby city raccoons *really* don't need any help finding food—there's some indication that city raccoons are heavier than their rural counterparts. A research article in *Conservation Physiology* published in June 2018 determined that access to "anthropogenic food waste," or garbage, leads to elevated body mass in raccoons.

Simon's not surprised to see raccoons taking advantage of the situation this way. "Raccoons are smart animals. Plus they are generalists. They are omnivores. So they eat anything," he says. "If they are living in more of a natural area, they're perfectly content to eat what we plant in the park, nuts, berries, small eggs from birds. But certainly they will go into trash if it is available to them."

This garbage-can-raiding tendency—as well as their coloring—has led some to dub them "trash pandas." To that end, the new compost bins rolled out by the Department of Sanitation in 2016 came equipped with a lockable latch, in part to thwart raccoons' scavenging tendencies, which were highlighted in a New York City Sanitation Department video featuring a human in a raccoon suit unsuccessfully trying to open the lids.

Keeping raccoons away from discarded food stuffs inevitably points them toward a more natural food source, which Simon suggests could be a boon for the city's ecosystem. "If raccoons are plucking seeds and nuts from a tree, they may in their droppings help spread seeds on the ground to help regenerate the forest."

Sure enough, raccoons can be found in New York City's more natural settings. In fact, for anyone willing—or maybe even brave enough—to walk through Central Park after dark, it's almost difficult *not* to encounter a raccoon, either in the Ramble or other wooded areas of the park. Their chattering is unmistakable in the quiet of the park at night. Plus, they don't exactly run from or avoid people. Some, usually those who have been fed, will even approach people in hopes of a handout.

Another surprisingly reliable spot for raccoon sightings in Central Park is the Delacorte Theater, home to Shakespeare in the Park. Remarkably, these raccoon sightings often happen *during* the live performances. Apparently, a family of raccoons live right underneath the stage, their glow-in-the-dark eyes visible to the audience. Reports indicate that raccoons have crashed performances of both *The Tempest* and *Measure for Measure*. Sadly, the theater declined to offer comment.

This phenomenon has even sparked a parody Twitter account, @ParkRaccoon. This account aside, there aren't many raccoon heroes or even tributes in pop culture. Instead, they are often portrayed as rascals, nature's outlaw. They are also not very popular with the locals. In a 2018 Instagram story posted by Bronx rapper Cardi B, for example, she asked, "Where the fuck these raccoons coming from?" before going on to say, "We got to get rid of these motherfucking raccoons." Her commentary, while hopefully in jest, underscores the point that city raccoons are not beloved. They're trash pandas, a nuisance. Seeing one is not necessarily a rare or even pleasing experience. For whatever reason, they don't always feel like "real" wildlife.

But raccoons deserve a second look. They are procyonids, which if nothing else, is a cool word. They resemble a miniature bear–dog hybrid, but with opposable thumbs, glow-in-the-dark eyes, and super-high IQs. It's kind of astonishing that raccoons are not everyone's favorite animal, but maybe the numbers are the problem. Perhaps raccoons would be more beloved if there were fewer of them. However, raccoons are so ubiquitous and plentiful precisely because they are flexible as a species, which should not count as a strike against them. They very well can (and do) live in parks and wooded areas. They just so happen to be able to live in scaffolding and garages too. They can forage for fruits and nuts in the wild, or they can subsist on Cardi B's garbage. Eating readily available and abundant trash doesn't mean raccoons are any less wild or less special. On the contrary, it only means they are clever, resilient, and determined to thrive.

The Legends

New Yorkers have always loved their celebrities, including certain historically famous and infamous nonhuman critters, which were fawned over and covered breathlessly in the media almost as much as their human counterparts. Although some took a bite out of the Big Apple while others got chewed up and spit out, all of them remain New York City legends.

Latin Name	Collective Noun
Alligator mississippiensis	a congregation of alligators

Alligators

Alligators are the subject of one of the original urban legends, and over the years these reptilian predators have invaded the imaginations of countless New Yorkers. As with a lot of tall tales, there's a bit of truth to this one. Indeed, New York City has been home to honest-to-God alligators, some even lurking in the sewers.

The most famous of these gators appeared way back in 1935, when on February 9 a seven-foot, 125-pound behemoth was discovered in the East Harlem sewers. And just to be clear, this is not merely some story handed down between neighbors over the years. This was reported in the *New York Times*.

Some local boys were shoveling snow into a manhole when suddenly they saw a thrashing they soon realized to be an alligator. Using a clothesline as a slip knot, they pulled the massive creature up from the sewer. A crowd of neighbors joined (because who wouldn't?).

Sadly, things did not end well for this particular alligator. Perhaps out of an abundance of caution, the boys proceeded to beat it to death with their shovels. Later that day, the city had the carcass removed and destroyed before any photographers thought to capture the moment. Still, a legend was born.

"The alligators in the sewer story is one of the greatest, most iconic, and defining New York City phenomena," says former Manhattan Borough historian Michael Miscione. "It just needs to be celebrated." And when Miscione says "celebrated," he means it. In 2010, he successfully petitioned the Manhattan Borough president to proclaim February 9 as Alligators in the Sewer Day.

According to the legend, which is echoed by Miscione, alligators most likely came to the city by way of wealthy families who, after vacationing in warmer climates, returned with baby alligators as souvenirs. But that wasn't the only way to get an alligator to New York City: in the first half of the twentieth century, you could also mail-order a tiny alligator for only $1.50. However, these exotic babies would continue to grow, eventually becoming too large for apartment life. "The theory is eventually someone got sick of this thing in the bathtub or whatever and dumped it down the sewer," says Miscione. From there, according to the legend, the alligators roamed the murky subterranean waters of the city, reproducing and subsisting on a diet of plentiful rats.

The Harlem alligator was no isolated incident. In 1937, a five-foot alligator was pulled from the East River. A week later one was found crawling around a subway platform in Brooklyn.

In 1959, the sewer alligator saga was given new life in Robert Daley's *The World Beneath the City*. The book profiles New York City's infamous superintendent of sewers, Teddy May, who described witnessing whole congregations of alligators below street level: "The beam of [May's] own flashlight had spotted alligators whose length, on the average, was about two feet. Some may have been longer. . . . The colony appeared to have settled contentedly under the very streets of the busiest city in the world." The book goes

author exists—and allegedly in New York City— even if very few people can prove it.)

One current, very visible sewer alligator reference resides in Tom Otterness's art installation *Life Underground*. These sculptures, found near the subway platform at the Fourteenth Street Station on the Eighth Avenue line, depict a variety of scenes, including an alligator reaching out from underneath a manhole cover to snatch a man for dinner.

Alligators in the sewer have become an undeniable part of New York City's folklore. But could

> ❝
> ## The colony appeared to have settled contentedly under the very streets of the busiest city in the world.
> ❞

on to describe alligator hunts with arsenals of rat poison and .22 rifles. Perhaps these "sewer safaris" eradicated the scourge of alligators then.

Regardless of whether alligators currently reside in the city's sewer system, the lore continues. A few years after Daley's book, sewer alligators popped up again, this time in Thomas Pynchon's 1962 debut fiction novel *V.* The lead character, Benny Profane, works for New York City's Alligator Patrol, where two-man teams search underground for alligators, one with a flashlight, the other with a shotgun. (Pynchon is like a legendary sewer alligator himself in that there is evidence that this famously reclusive

they really exist down there as a population? Could they hunt? Could they reproduce? Could they thrive? Loren Coleman of the International Cryptozoology Museum in Portland, Maine, believes alligators are down there. Coleman has written a few books on the subject and regularly appears on TV shows about mysterious animals. According to an email, he says, "Alligators in the sewers are neither rumor, folktale, or myth, but a real part of the underground world of some of our larger urban centers." Though adamant, his message does not provide any proof of a healthy and ongoing population of New York City alligators.

Research shows that alligators can detect minuscule vibrations in the water through dome pressure receptors on their faces. That is to say, they don't rely solely on sight for hunting and therefore wouldn't be totally "in the dark" looking for food in those light-deprived sewer systems. This is further backed up by the fact that alligators very often hunt at night.

While alligators probably prefer a climate more hospitable than that offered by New York City, the sewers themselves just might be warm enough. And we shouldn't forget that alligators survived the last Ice Age, which was probably a bit colder than any winter in the Northeast. So it's probably foolish to question the adaptability of a creature that has existed unchanged for so long.

Jim Nesci, an alligator expert from the Chicago area who worked with crocodile hunter Steve Irwin, believes it's possible for a single alligator or two to exist in sewers, for a little while anyway. As he points out, though, alligators have a hard time digesting food in temperatures below 50 degrees Fahrenheit, making the prospect of surviving many New York City winters, even underground, unlikely. There's also the problem of finding materials for nests and sufficient food. There are millions of rats in New York City but not that many in the sewers.

In the end, an alligator could probably survive in the sewer for a while, but any kind of significant congregation of alligators, any kind of healthy and sustainable population, probably wouldn't fare too well.

Nonetheless, on August 23, 2010, an eighteen-inch alligator was spotted emerging from a sewer drain in Queens. "It's a big mystery," said police spokesman Officer James Duffy. "It could have been dumped from a car or it could have come out of a sewer." Then a few years later, in 2015, a medium-size alligator was found crossing Ninth Avenue in Manhattan, around 205th Street.

This is the rhythm of New York City and its alligators: every few years they make real-life appearances and then disappear for entire decades, taking up residence instead in whispered stories of lore, only further solidifying their legendary status.

Latin Name	Collective Noun
undetermined	undetermined

Collect Pond Monster

I n Lower Manhattan, just north of City Hall, there once was a forty-eight-acre freshwater source known as the Collect Pond. It was once the largest body of water in Manhattan, about half the size of the current Central Park reservoir. It supplied clean drinking water to early colonial settlers as well as the Lenape people who preceded them. According to a gruesome legend, it was also home to a fearsome creature with both a taste for human flesh and a flair for the patriotic.

In his book *Strange and Obscure Stories of New York City*, Tim Rowland describes the Collect Pond as "a postcard in waiting, nestled in low, rolling hills, whose shoreline was dressed in a scattering of trees, church steeples, and a handful of trim, two-story cottages."

It was decidedly less picturesque during the Revolutionary War, when the Hessians and British occupying forces kept their infamous Bridewell, a prison, on its shore. Many American soldiers would die here from wind and cold exposure while awaiting trial. It was also the rumored site of a strange and mysterious murder. According to the legend, a Hessian soldier tried to swim across the pond one night but was instead dragged down forty feet to the pond's soggy bottom by an otherworldly creature that would come to be known as the Collect Pond Monster.

The details are murky. The 1897 book *Old Wells and Water-Course of the Island of Manhattan* by George Everett Hill takes a sober look at the situation: "Tradition's younger and more matter-of-fact sister, history, remarks that 'from time to time persons who had drunk too deeply fell from its banks and some of them were drowned.' Viewed in this side light it seems highly probable that the tremendous monsters were of the delirium tremendous variety."

The legend could have also been a politically motivated tall tale. The Hessians were the Germanic mercenary force hired by the British to quell the American Revolution. They too were somewhat monstrous, at least to the early Americans. These freelance soldiers numbered more than thirty thousand throughout the continent, composing roughly one-quarter of the total British force. They didn't fight for national pride or love of king, but for money. Unsurprisingly, these German goons were not very popular in New York City or anywhere else in the colonies. They were brutal, efficient, and clearly winning the war.

It would be accurate to say that the young, untrained American armies did not fare well in New York City engagements. The Battle of Brooklyn, for example, nearly broke General Washington's campaign entirely. Truthfully, a

lot of the American "highlights" in Revolutionary War–era New York City involved clever escapes more than anything resembling victory or even glory. Even if the Collect Pond Monster were real, eating one Hessian soldier wasn't going to be a determining factor in this war. The whole thing was probably all just a hoax, a legend, a bit of psychological warfare carried out by the outnumbered and outgunned American forces hoping to put a scare in their opponents. Eventually, the war would end and New York City would find itself free of occupying forces. A few short years later, it would also be free of its infamous freshwater pond.

By the early 1800s, the Collect Pond had become dangerous for a host of non-monster-related reasons. This time, the health hazards posed by industrial runoff and human waste were the culprit. City planners decided that the nearby tanneries and slaughterhouses, which often dumped animal bones and other offal directly into the city's drinking water, were to blame. In what is considered one of the city's first public works projects, the pond was filled in with dirt, sadly covering up any potential for monster remains or evidence to be discovered.

Soil management and water tables were not factored into the decision to fill in the polluted pond, and in short time the former pond became a swampy, muddy mess. It was bad for building foundations but ideal for mosquito breeding grounds. The infamous Five Points neighborhood, home to the Dead Rabbits and other gangs of New York, took up residence in the area, largely because nobody with any money or standing would choose to live there. No monsters were reported at this time, but with the neighborhood said to average one murder per day, it was still a scary place to live. There were other health hazards too—improper sanitation, rampant disease—and a few of New York's worst cholera outbreaks had their origin in this putrid ward.

Soon this gang-infested neighborhood would also have to go. By 1902, New York City erected its second Tombs prison on the site (the first one sagged significantly into the former pond and had to be demolished). This prison, with its presumably better foundation, was home to plenty of killers, though at least these monsters were safely behind bars.

Today, Five Points is long gone, the jails have been updated, and there are no signs of monsters. With the exception of the appropriately named Collect Pond Park, most traces of the original body of water have dried up too. Opened in 2014, this small, one-acre park boasts a reflecting pool to mimic the pond that once stood there. It's a place where New Yorkers can sit, relax, and perhaps even gaze below the surface into the more deadly depths of the city's history.

Latin Name	Collective Noun
undetermined	undetermined

East River Monster

One morning in the summer of 2012, Denise Ginley was walking along the East River Esplanade when she noticed an animal corpse washed ashore on a small patch of sand in Manhattan, just under the Brooklyn Bridge. The mysterious creature was long dead, bloated with the water that carried it there. A photographer by trade, she quickly took some pictures.

Gothamist, a local news website, ran Ginley's pictures with its own accompanying article in which it called the creature a "rat monster." Truthfully, nobody could really say what it was. With no definitive answers, it then quickly came to be known as the East River Monster, for the body of water it had been found near.

It was a captivating moment for New Yorkers, but this story had really started four years earlier, in the summer of 2008, when a similarly cryptic critter washed ashore one hundred miles east of New York City at Ditch Plains Beach, a popular surfing destination near Montauk, New York.

Some thought that 2008 creature was a raccoon; others said it was a turtle without its shell. And still others suspected something far more sinister: Montauk isn't far from the shadowy federal animal research facility on Plum Island, where, according to rumor, a secret biological weapons program targeting livestock was conducted during the Cold War. Conspiracy theories abounded.

Noted cryptozoologist Loren Coleman weighed in and dubbed the animal the Montauk Monster. From there an internet craze was born. Gawker went unapologetically deep on the topic. *The Atlantic, Huffington Post*, and Fox News all covered the story too. Facebook fan pages sprung up. Memes were born. People were mesmerized.

Richard Lawson, writing one of the many Gawker articles on the Montauk Monster, captured the appeal perfectly when he wrote that "monsters are the world's troubles made manifest" and that these stories resonate with people "because we all knew, deep inside all along, that monsters were real." It's fair to say that the Montauk Monster was still fresh in many people's minds when (its cousin?!) the East River Monster appeared in Manhattan.

What's more, New York City is an ideal setting for a monster. It's even a bit poetic. Here is this great metropolis that tamed nature yet could not explain this new wild arrival at its shore. Perhaps the years of environmental pollution had finally come back to haunt New Yorkers, and the East River Monster was a toxic by-product from one of the city's EPA Superfund sites, such as Newtown Creek in Queens or the Gowanus Canal in Brooklyn. Or maybe some local maniac

> **"**
>
> ## New York City is an ideal setting for a monster. It's even a bit poetic. Here is this great metropolis that tamed nature yet could not explain this new wild arrival at its shore.
>
> **"**

scientist, spurned by years of living alone in the Big City, made the East River Monster in his apartment. Or maybe it was all just part of some elaborate marketing scheme hatched nearby on Madison Avenue.

Eventually, the official word came down from the New York City Parks Department: it was actually a pig that someone had cooked and then discarded in the river. *New York Magazine* summed up the collective incredulity with a July 24, 2012, headline that read, "We're Supposed to Believe the New East River Monster Is Just a Pig?" Gothamist reached out to a Cornell professor who said it was a dog. Gawker never seemed to decide on any definition that didn't include the word *monster*. As the debate continued to rage online, the Parks Department had the carcass incinerated, leaving only more questions and mystery.

Regardless of its true identity, locals were impressed with, intrigued by, and opinionated about this strange new creature. And in true New York fashion, nobody was surprised that the city was capable of producing such a monstrosity.

Latin Name	Collective Noun
Tursiops truncatus	a pod of dolphins

Dolphins

New York City's dolphins are a cheerful reminder of how much environmental quality has improved. The water is cleaner. There's more food for them to eat. There are even boats offering dolphin sightseeing tours, though standing on the shore near Coney Island is itself a pretty good opportunity to spot the joyful marine mammals. Generally, it has been good news for the city's dolphins.

However, the unlucky local dolphin who wandered into Brooklyn's Gowanus Canal in January 2013 was a reminder of how much cleanup remains to be done. The dolphin, whom the locals nicknamed Mucky, was old and very sick when he arrived. He was separated from his pod, clearly lost, and stranded in the worst possible waters.

The Gowanus Canal was originally the Gowanus Creek. Legend has it the oysters there would grow to the size of dinner plates. The creek was fed by nearby water flowing downhill from the appropriately named Prospect Heights, Cobble Hill, and Park Slope.

The Gowanus Creek also played a major part in the Battle of Brooklyn during the Revolutionary War. In fact, some unaccounted for American soldiers from the First Maryland Regiment are still buried in the surrounding neighborhoods. Nobody knows where exactly.

In the 1860s, the creek was transformed into a 1.8-mile canal, running from Red Hook to Boerum Hill. Almost immediately, it was both a commercial success and an ecological nightmare. For starters, the streams and tributaries that once flowed into the creek were plugged up, effectively cutting off oxygen to the waterway. The city replaced this flow with raw sewage to try to flush out the canal, later replaced by combined sewage overflow, which accounts for the ongoing pollution to the canal. Plus, there were all those decades of heavy industry conducted without a whiff of environmental oversight.

By the twentieth century, the canal was found to have high levels of pesticides, mercury, and cancer-causing PCBs. A ten-foot layer of industrial sediment known as black mayonnaise lined the bottom. (It's where Mucky got his name.) Plus, any time it rained, raw sewage from adjacent neighborhoods would be added to the mix.

As Eric Sanderson, author of *Mannahatta*, told an audience at the Brooklyn Historical Society in 2018, "nobody paid to clean up the mess they made."

Locals sarcastically renamed the canal Lavender Lake, referring to its unnatural appearance and color. Its putrid waters stood stagnant for decades, and—no surprise—it smelled terrible. It wasn't until a flushing station was repaired in

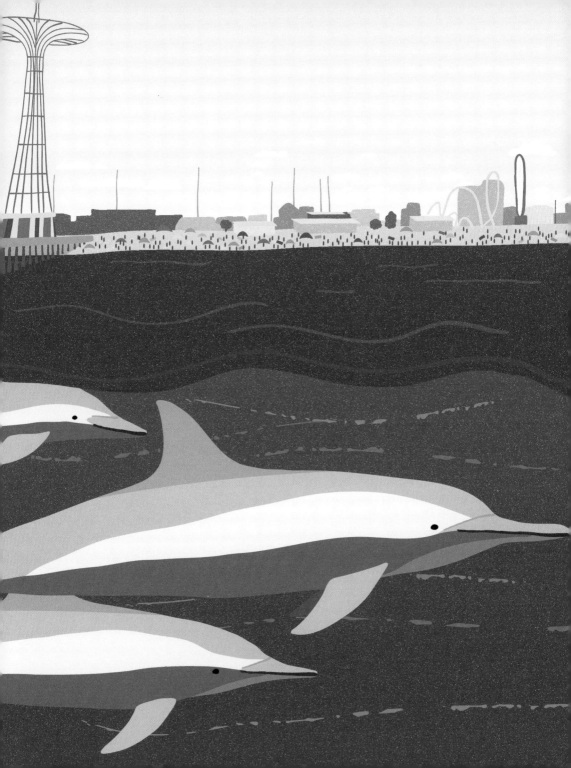

1999 that the waterway had any movement to it. Suffice to say, it was not a very conducive environment for wildlife.

Eventually, the EPA designated the Gowanus Canal as a Superfund site in 2010, meaning the federal government saw the waterway as a candidate for cleanup based on its threat to human health and the environment. In most places, this sort of ignominy might deter real estate speculation, but not in Brooklyn, baby. The shore of the canal is lined with wedding venues, restaurants, and bars, making it more of a "super fun" site. There is even a Whole Foods. The cleanup had barely begun and developers were already dreaming of the new Venice of Brooklyn.

Sadly, Mucky the dolphin didn't last long in the canal. He died a day after arriving. A necropsy indicated that he was very old and pretty sick when he got there. Even if the canal's toxic waters weren't directly to blame, they certainly didn't help. But cleaning up is a process. It won't happen overnight. Every so often a sad reminder will float to the shore reminding New Yorkers of how much work remains.

However, by all indications, the future of the Gowanus Canal is one of a healthier waterway. There are already some signs of recovery. Oysters, white perch, herring, striped bass, crabs, jellyfish, and anchovies have all returned, though

their life expectancy is about half the length of animals that don't live in a Superfund site.

Leading this turnaround is the Gowanus Canal Conservancy. They see a multifaceted approach, including regenerating the urban forest, planting absorbent gardens, and incentivizing green roofs to minimize storm runoff. They are also planning for a future of pedestrian esplanades, kayak launches, and loads of new open spaces. There's also some talk of daylighting Brouwer's Brook, a buried stream that once flowed above ground and now flows in the Conservancy's own basement.

Andrea Parker, Executive Director of the Gowanus Canal Conservancy, believes the underlying ecology, geology, and hydrology of the site need to be understood and even embraced as the site evolves into its next iteration. She laughs it off when people suggest simply filling in the Gowanus Canal with dirt. "Well then the entire neighborhood would flood," says Parker. "We need to accept that this is where the water goes. It's a really rich and vibrant place because of that. And we need to embrace it and celebrate that."

Improving the canal will not only help the neighborhood, but also the greater harbor. That's great news for all species, including dolphins, and not just the ones who get lost in the canal.

Latin Name	Collective Noun
Elephas maximus indicus	a herd of elephants

Elephants

On December 6, 1902, Whitey Ault, already drunk at just noon, clambered up onto the neck of his elephant, Topsy, and rode her away from the animal's confines at Coney Island and up through the traffic on nearby Surf Avenue.

It was quite the scene. More and more spectators joined at every intersection, not only because *holy shit, there's an elephant walking up the street!*, but also because this particular pachyderm was no ordinary elephant but rather a known killer of men.

Earlier that year, in May, Topsy killed James Blount at a Forepaugh and Sells Brothers Circus in Bedford Stuyvesant, Brooklyn. And no offense to any of Blount's descendants, but he kind of had it coming. Blount was known to hang around the circus, though not in any official capacity. He drank a lot, even by carnie standards. True to form, he was drunk on that fateful morning when he let himself into the elephant menagerie, reportedly to offer the animals some whiskey.

"Here, Topsy, wake up," Blount is reported to have said. "It's morning. Have a drink!"

The half-asleep elephant ignored Blount at first, which prompted the man to begin hitting Topsy's trunk before throwing sand in her face and finally putting out his lit cigar on the tip of her trunk, which, like with all elephants', is extremely sensitive. Enraged, Topsy wrapped her trunk around Blount's waist, lifted him in the air and slammed him to the ground, killing him instantly. Accordingly, there was not much outrage over Blount's death. Reports from the next day's *New York Times* and *New York Tribune* took Topsy's side in the matter.

However, just a week later, as Topsy was being led from a train in Poughkeepsie, New York, a local man tickled her behind the ear, which sent her into another rage. She wrapped her trunk around the man's waist and lifted him high in the air only to be saved at the last minute by a nearby reassuring handler. And there were other stories about Topsy too, including unconfirmed reports that she killed bystanders in Texas.

Fair or not, she had a bad reputation.

Topsy was born in Southeast Asia in 1875 and captured shortly thereafter. She was named after a character from *Uncle Tom's Cabin* and shipped to America where she would be given a string of horrible handlers. It's less a wonder Topsy went ballistic and more surprising it didn't happen with greater frequency among other captive animals. Maybe Topsy was predisposed to be a bad elephant, or maybe she never had a chance.

After the Poughkeepsie incident, Topsy was sold and sent to Coney Island where she was put to work, often moving stage pieces and giant

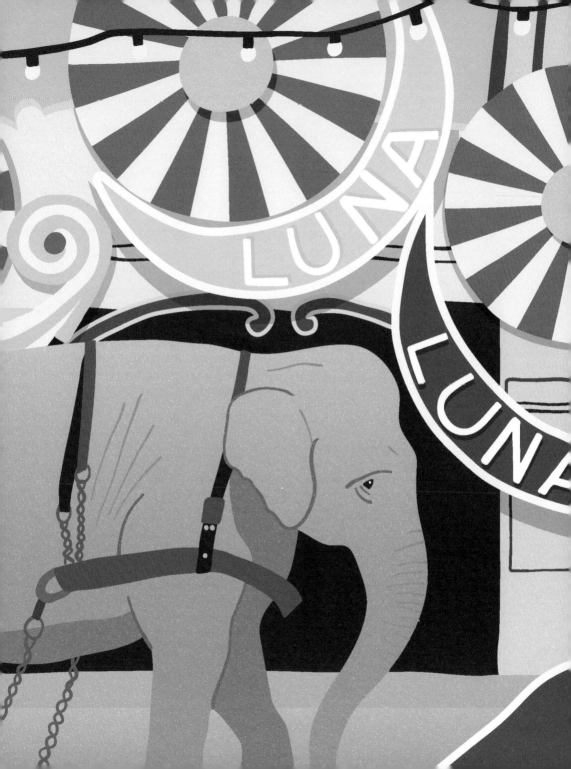

timbers for what would eventually become Luna Park. Because of her reputation, there wasn't a long line of applicants to be her handler. So the job fell to Whitey Ault, a brash young elephant handler who drank too much (a common problem at the time).

Although it was by no means a perfect arrangement, Topsy had been given another chance to live in relative peace. Yet here she was enduring another sauced-up man, who on this December morning had her stomping up Surf Avenue toward the police station, of all places.

Down on the street level, Officer Thomas Conlin of the New York Police Department (NYPD) threatened to arrest Ault if he didn't stop and bring Topsy back to her menagerie. Hearing this, Ault slid down off the elephant's neck and dared Conlin to arrest him, threatening to turn Topsy on the crowd. Conlin responded with his own threat, drawing his pistol and promising to shoot Ault dead should he do so.

Moments later, Ault was in handcuffs. At the sight of her handler being taken into the jail, Topsy stormed the building, wedging her massive, ten-foot-tall frame into the police station entrance. Reports say she let out such an angry and deafening trumpet that the crowd on the street scattered and the cops inside the station ran for shelter in the stairways and empty cells.

Eventually, Frederick Thompson from Luna Park came down to bail out Ault, on the condition he would escort Topsy the half mile back to her enclosure.

With Topsy returned to Luna Park, the streets were safe once more. However, the long-term situation was untenable, and in the coming weeks, it was decided that the infamous killer elephant would herself be executed.

This kind of cruel spectacle would be impossible to imagine today. However, this was several decades before federal laws preventing cruelty to animals or organizations like PETA existed. The American Society for the Prevention of Cruelty to Animals (ASPCA) did exist at the time, and was actually on hand to ensure things went as humanely as possible for Topsy. They successfully convinced Thompson not to sell tickets to the event but, unfortunately, were not able to deter the execution entirely.

On January 5, 1903, some fifteen hundred people gathered in what the *New York Times* described as the "dreary, out-of-season pleasure park" to watch the grisly spectacle unfold. It was said Topsy refused to take the final steps to her death. According to Michael Daly's book, *Topsy*, Whitey Ault was sent for to coax the elephant to her execution site. Ault refused the twenty dollars offered him, however, and, through tears, insisted that he wouldn't do it for a thousand.

And so Topsy was chained and fitted with electrodes right where she stood. After being fed three carrots laced with nearly five hundred grams of potassium cyanide, she was hit with sixty-six hundred volts of Edison electricity (though Thomas Edison himself had no association with the matter). The giant and massive creature, not meant for this corner of the world and certainly not this type of treatment, stumbled forward amid the shock of electric judgment, and took her final bow before the assembled crowd.

Latin Name	Collective Noun
Aix galericulata	a paddling of mandarin ducks

Mandarin Ducks

In the fall of 2018, an exotic duck appeared in Central Park. He was a mandarin duck, a species native to East Asia. His plumage was a bright, colorful contrast to his native counterparts. He looked like a duck that had been designed by Roy Lichtenstein or maybe Gucci. Online, he was dubbed the "hot duck." In real life, crowds flocked to see him. They took pictures. They watched him swim, dry his feathers, be a duck—only hotter.

More than likely, the hot duck was an escaped pet. He had banding (similar to a zip tie) on his right leg, which allows wildlife experts to quickly identify animals that are lost or were previously injured. The hot duck likely did not fly to Central Park all the way from Japan but rather from New Jersey—it wouldn't exactly be the first time a suburbanite moved to the city for a fresh start.

Regardless of where he came from, New Yorkers adored their hot duck. They loved how he was immediately assertive with the local New York ducks, how he appeared to showboat for the crowds, how he would sometimes visit the suburbs on the weekends, and how bold and brash he looked. The shoreline around the pond where he lived in Central Park became a scene. Photographers set up shop. Crowds would wait hours for a glimpse of him. Every local news outlet covered the story, as did TMZ and the *Daily Mail*. Quartz built a website to track his progress.

As hot as this mandarin duck was, he wasn't the first bird to appear suddenly and captivate New Yorkers. In 2015, a painted bunting—an impossibly rainbow-color finch—had birders at Brooklyn's Prospect Park mesmerized for days. Back in 1998, a broad-billed sandpiper, presumably lost from Europe, took up residence in Jamaica Bay Wildlife Refuge for two weeks.

It may be surprising to learn, but New York City is a spectacular place to bird-watch. Not only is it a great year-round habitat for all kinds of shorebirds, raptors, and waterfowl, but the city also sits right smack in the middle of the Atlantic Flyway, one of four migratory bird superhighways in North America. New York City and its parks are often visited by indigo bunting, scarlet tanagers, green herons, even yellow-bellied flycatchers. That's all to say, plenty of hot birds already live here, with even more passing through on a regular basis.

Because of this, the hot duck's instant celebrity ruffled more than a few of the feathers of the established New York City bird scene. It wasn't that these folks were anti–hot duck. Rather, they worried that *true* New York City birds were being overlooked.

In an open letter to the mandarin duck, Andrew Del-Colle of the National Audubon Society wrote:

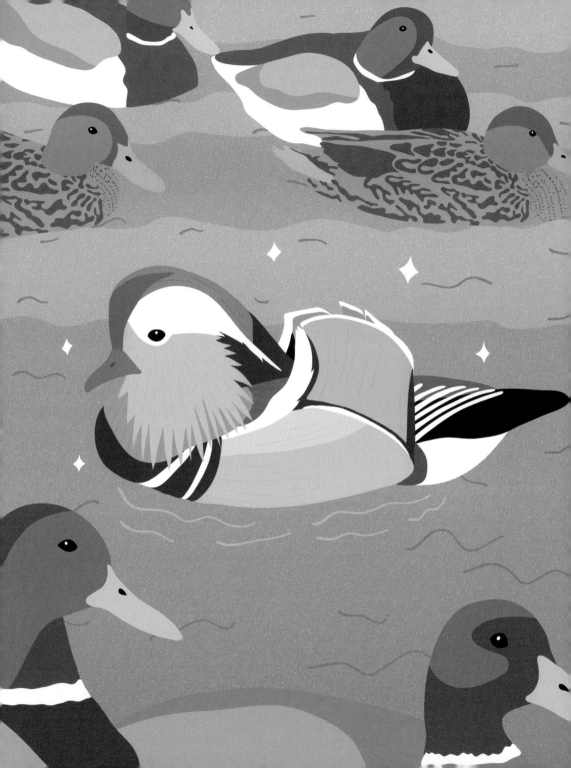

"Your non-native garb is showing up our most beautiful native duck. Don't think that Wood Duck doesn't mind. He does." And to be fair, the wood duck is kind of hot too, in a mandarin-duck-designed-by-L.L.Bean kind of way.

Plus, it turns out New York City was home to a handful of these mandarin ducks already, including ones in Prospect Park and the Bronx

lunch break from the rat race to see this crazy hot duck everyone was talking about instead. Tourists could easily divert from Times Square to experience some unique New York City phenomenon, something with which even the locals were obsessed.

The hot duck was oddly beautiful and definitely out of place, which made him right at

> ❝
> # The hot duck's instant celebrity ruffled more than a few of the feathers of the established New York City bird scene.
> ❞

Zoo. Yet something about this Central Park mandarin duck was different. Writing for Gothamist, which broke the hot duck story, Jen Carlson described the scene at the park as being "cult-ish" with "an apocalyptic circus vibe."

Truly, it was just a duck, but it was one that brought New Yorkers out to the park. Maybe it was the proximity to Midtown, allowing office workers to take a

home in Manhattan, a place where nobody's really from but everyone's welcome. And even if the hot duck wasn't wild or native, he was still as unpredictable and thrilling as "true" wildlife. That's because he could have up and left at any time: he could have been snatched by a hawk or moved to Morristown. There was an excitement and urgency to the hot duck. After all, he should never have been in Central Park in the first place.

Tigers

On October 3, 2003, the NYPD discovered a four-hundred-pound Bengal tiger named Ming living in an apartment of the Drew–Hamilton public housing projects on West 142nd Street in Harlem. Both the apartment and the jungle cat belonged to Antoine Yates, a self-described lover of all animals. By the end of that fateful day, however, both he and his tiger would find themselves behind bars.

Yates first purchased Ming from an animal dealer in Minnesota when the tiger was about eight weeks old. For the next three years, Ming lived alongside Yates in his relatively spacious five-bedroom apartment. Ming would follow Yates around like a shadow, even resting his giant tiger head in Yates's lap while the man meditated. Truly, it was a monastic life for Yates, who left the house only for an hour a day to buy food for his pet tiger, usually around twenty pounds of raw meat and bones.

"Some people like cars. Some people like shoes," says Yates. "I love animals." That's why it came as no surprise when Yates found an injured cat outside his apartment building, he decided to bring it home to nurse it back to health. To hear Yates tell it, the cat, now named Shadow, actually found him.

"I decided to keep the cat, but I kept him isolated in a single room," said Yates in an interview with Animal Planet. "My thing was that OK, I can't let this cat run around loose, because, mind you, I had a seven- or eight-foot alligator and I had a tiger, you know what I mean?"

Oh yeah, that's right. Yates also had an alligator in that apartment. Technically, it was a caiman, which is sort of like an alligator, but that's beside the point.

Before long, Ming caught sight of Shadow, and in an instant the tiger's ancient and hardwired instincts took over. The big cat lunged to devour Shadow, and foolishly, Yates tried to stand in the way. Ming knocked Yates to the ground and put his massive jaw around the man's neck. "Everything just froze for a second. I could feel his hot breath on my neck. But he didn't apply pressure. It was more of a 'hold you' bite," says Yates. "My whole life flashed in front of me. I mean you literally got a tiger on your neck. You feel instant death at that point. It's an unexplanatory feeling."

The tiger quickly let go of Yates. Incredibly, though, Yates persisted in obstructing Ming's pursuit of Shadow. Finally, Ming acted like a tiger and sunk his powerful teeth into Yates's leg for a full two minutes.

Instead of panicking, Yates calmly commanded the tiger to relent by firmly saying no. By the third attempt, this actually worked. Yates secured Ming in a bedroom and took himself to Harlem Hospital Center where he told the attending staff he had been bitten by a pit bull, which of course, nobody believed.

The next day, the NYPD, tipped off by the hospital, showed up at Yates's apartment to investigate. They didn't find Yates there. He had fled to his mother's house in Pennsylvania. But when the cops drilled a hole in the door to look inside, they did find Ming.

Officer Martin Duffy rappelled down the side of the building with a tranquilizer gun slung over his shoulder and shot Ming once through the open window. The tiger let forth a stunning roar, then eventually slumped to the floor. With the massive feline sedated, the rest of the animal control team came in through the front door and together removed the slumbering beast right down through the public elevator.

By this point, a crowd had assembled on the street. Some neighbors were shocked, while others swore they had always known. Yates quickly turned himself in and would eventually serve six months in prison followed by five years of probation. All these years later, Yates swears his bond with Ming is what let him live to tell the tale.

Coincidentally, on the same exact day Ming bit Yates, Roy Horn, of Siegfried & Roy, was also attacked by a captive tiger, one that would not relent on command, very nearly killing the famous tiger expert in front of a traumatized audience in Las Vegas. By comparison, Yates got off with a scratch.

To be fair, it seems as though Yates treated Ming about as well as a tiger living in a Harlem apartment could ever hope to be treated and maybe even better than some New Yorkers treat their legally owned pets. On the other hand, keeping a tiger in a New York City apartment is a spectacularly bad idea. It's not good for the tiger and it's certainly not good for the neighbors. Plus, it's super illegal. Still, for a few years there, these two lived together undetected. Perhaps the sheer size of the city, the overwhelming glut of buildings and rooms and spaces that could never be fully accounted for, acted as a camouflage for this unusual arrangement.

Eventually, Ming was moved to a big-game rescue facility in Berlin, Ohio, whereas Yates moved to Las Vegas. He says he plans to relocate to North Carolina to create a nonprofit dedicated to wildlife research.

Some guys just really love animals.

Latin Name	Collective Noun
Pygoscelis antarcticus	a colony of penguins

Penguins

In the late 1990s, zookeepers at the Central Park Zoo noticed two male chinstrap penguins, Roy and Silo, acting very fond of one another. "Ecstatic behavior" was the technical term. The two penguins would entwine their necks around and vocalize with each other. They even tried to start a family. Call it anthropomorphizing, but yes, the penguins were fully gay and madly, ecstatically in love.

Typically during penguin mating, the male prepares a nest, which the female inspects before deciding to pair with her suitor. Sometimes, however, penguins break this heteronormative mold, which is all to say, Roy and Silo were not the first gay penguins. British explorer George Murray Levick observed homosexual behavior in Antarctic penguins back in 1911. Levick described what he saw as "depraved" and his subsequent report was suppressed from the public view. The gay penguin phenomena would be closeted for nearly another century.

In 2004, the *New York Times* outed the flightless lovebirds, who at that point had actually been an item for six years. The paper referred to their union as a "love that dare not squeak its name." In the decades after the transformative Stonewall riots, New York City had become an even more tolerant place for people and, yes, penguins of all orientations. Still, that was not the case for much of the rest of the country. In fact, it would take another nine years for the Defense of Marriage Act to be ruled unconstitutional and for gay marriage to be made legal nationwide.

The *Times* article, however, was lighthearted and carefree, celebrating the city's newest celebrity same-sex couple. It also introduced the world to Tango, the adopted daughter of Roy and Silo. Before Tango, the guys were so determined to start a family that they tried to incubate a rock they thought was an egg. Their enthusiasm for parenting prompted the zookeepers to entrust them with a fertilized penguin egg that needed a doting parent to help hatch. And just like that, presto, Tango, they were a family.

If it all sounds like a perfect premise for a children's book, it should come as no surprise that it became one. Justin Richardson and Peter Parnell's 2005 *And Tango Makes Three* extols the inherent goodness of adoption through the unlikely story of Roy and Silo giving young Tango a chance to thrive in life.

Sadly, though unsurprisingly, this book received some significant backlash. A group of concerned parents in Shiloh, Illinois, who clearly had a lot of free time on their hands, raised alarm bells about the book. They didn't want *And Tango Makes Three* banned outright, just maybe moved to a more mature section of the library. They also

suggested that parental permission be required to check out the book.

Shiloh wasn't alone. Other towns and school boards banned *And Tango Makes Three*. The book had the unfortunate distinction of being placed on the American Library Association's Top Ten Most Challenged Books List between 2006 and 2010.

to gay parents of all species. However, as of 2015, the *Homosexuality and Science* blog stopped being one of them. Without so much as a closing statement, the blog simply stopped updating. Perhaps the author moved on to other projects. Or maybe the author made a new friend, someone fun.

> **66**
>
> # In the decades after the transformative Stonewall riots, New York City had become an even more tolerant place for people and, yes, penguins of all orientations.
>
> **99**

One particularly galling opponent to the waddling gay penguin agenda was the blog *Homosexuality and Science*, which in 2015 argued that Roy and Silo were actually not a same-sex couple but just friends who were definitely straight. The author says their coupling is probably "a pure friendship bond; two male buddies having great exploratory fun."

It's hard to imagine anyone wanting to deny a child in need of a loving family—penguin, human, or otherwise—but sadly there are countless challenges

Roy and Silo still live in the Central Park Zoo, though no longer as a couple. They are not the only gay penguins in the world, though they are certainly the most celebrated. Their unlikely family was even the inspiration for a 2009 *Parks and Recreation* episode. In the years since their successful adoption of Tango, zoos around the world have paired same-sex penguin couples with orphaned eggs. It's been a small triumph for tolerance, but an even greater victory for those adopted baby penguins who surely did not care what gender their parents were.

Latin Name	Collective Noun
Ailuropoda melanoleuca	an embarrassment of pandas

Pandas

Giant Pandas are native to south-central China, but this is a story about the first panda bear to visit America: Su Lin. This little critter was smuggled into the country as a cub in 1936 by the novice explorer Ruth Harkness of New York City. Su Lin, which is Mandarin for "a little bit of something cute," would eventually be sold to a zoo in Chicago. First, though, she would live in a Manhattan apartment for a month while enjoying celebrity status all over town.

Su Lin arrived in New York City to an American public fascinated with panda bears. Just a few years earlier, in the late 1920s, the Roosevelt brothers, Theodore and Kermit, had shot and killed a panda in the hopes of proving the animal's very existence. At that point, pandas were considered mythical, about as real as a dragon or a unicorn.

Bill Harkness, Ruth's husband, had gone to China himself in hopes of finding a panda, a living one he could bring home to the United States. He spent two unsuccessful years there before finally succumbing to throat cancer, alone, in a Shanghai hospital in February 1936.

At the time of his death, he and Ruth had been married ten years. They shared a posh Fifth Avenue apartment in Manhattan and a life of luxury, all of which evaporated when Bill's estate was settled by a spiteful stepmother who left Ruth with only a relatively small inheritance.

About a month later, in mourning and with considerably less money to her name, Ruth Harkness moved into a more affordable West Eighteenth Street apartment in Chelsea. It was there that she was visited by a British man named Gerald Russell, a friend her late husband had made in China.

Ruth informed Russell about Bill's demise. In expressing his condolences, Russell suggested to Harkness that she continue the expedition her husband had started. "Someone bearing his name should get the first giant panda," he said. Ruth agreed, later saying, "I inherited an expedition and what else could I do?"

Now if the idea of a New York City housewife who knew more about whiskey sodas than she did about animals or Asia jetting off to China to capture a live panda sounds crazy today, just imagine how it played in 1936. Nevertheless, Harkness parlayed what little inheritance she received into the trip and arrived in China, only a few months after her husband's death. She would describe herself to an American she met there as "a poor working girl who is on a madcap errand."

In Shanghai, she retrieved her husband's ashes as well as the garage full of expedition

supplies he had amassed, and she set out for the vast interior of China. Remarkably, just a few short weeks later, she returned from the high-altitude region along the Tibetan border with a live baby panda in tow.

"I was so sure I would succeed in a finding a baby panda that I took with me a nursing bottle and nipple," Harkness would later tell reporters. "It was not altogether luck nor a premonition." Indeed, bringing the milk bottle was a stroke of genius that no other explorer had considered.

they caught a train to Chicago and then a flight to New York City.

It was a big deal, this panda, the first Americans had ever seen. Harkness made Su Lin available to the media, including a press conference at Grand Central Terminal and a few radio appearances. She even invited reporters to her apartment in the Biltmore Hotel, where she and the bear would live as roommates for one month.

According to reports, Harkness would leave the windows open to help approximate Tibetan

66

'Someone bearing his name should get the first giant panda,' he said. Ruth agreed, later saying, 'I inherited an expedition and what else could I do?'

99

Harkness also understood exactly the altitudes where bamboo, a panda's favorite food, grows best.

Equally impressive was how quickly she got out of China with Su Lin, which Harkness was now referring to simply as Baby. Perhaps metaphorically, this baby panda stood in for the child she and Bill never had, a little bit of something cute by which to remember her late husband.

In early December 1936, Harkness and Su Lin triumphantly sailed for San Francisco aboard the Dollar liner *President McKinley*. From there,

weather, and she fed the panda bear a mixture of formula from a bottle. "Ordinarily, a panda prefers bamboo shoots for its diet, but the visitor to this country will have to learn to like something else," reported the *New York Times*.

Sadly, Su Lin would die of pneumonia two years later at the Brookfield Zoo in Chicago, well short of her life expectancy. The other captive American pandas of the day would all meet similar fates.

Realizing the leverage of panda diplomacy, China outlawed their export in 1946. Americans

> **Realizing the leverage of panda diplomacy, China outlawed their export in 1946. Americans wouldn't see another panda bear until shortly after Richard Nixon's historic trip to China in 1972.**

wouldn't see another panda bear until shortly after Richard Nixon's historic trip to China in 1972.

Harkness herself did not fare much better than her beloved panda, Su Lin. In the book *The Lady and the Panda*, Vicki Constantine Croke relays letters Harkness wrote to friends describing her postexpedition life as "wandering the lonely world. Searching sometimes one thing, sometimes another." Harkness continued: "Often it

seems to me that I have lost my destiny and am hunting again."

Ruth Harkness passed away in the summer of 1947 after battling years of alcoholism and financial troubles. Her body was discovered in the bathtub of a fancy Pittsburgh hotel room she had checked into the night before and most likely could not afford. Like her beloved Su Lin years earlier, Harkness died an unbefitting death in a strange and unfamiliar place.

The Workers

New York City has always been a hardworking town, but it's not only the humans who have labored and toiled. Indeed, the city was built on the backs of service animals and could never have grown to such heights without these industrious critters pulling their weight. Although the job descriptions have changed over the centuries, New Yorkers still find a way to make the most of their wild workers.

Latin Name	Collective Noun
Canis lupus familiaris	a pack of dogs

Dogs

Dogs were domesticated thousands of years ago. Nobody is exactly sure how or when it happened, but it is seen as a linchpin event in human history. Dogs allowed people to ditch both hunting *and* gathering. They allowed early peoples to settle down, plant crops, raise families, and build entire civilizations. In a way, humans owe everything—baseball, cities, trains, ice cream, books, and more—to dogs. This ancient partnership, as morphed and unfamiliar as it may appear today, is technically what laid the groundwork for society, for everything.

Admittedly, it's hard to imagine a flat-faced pug living in West Chelsea as having contributed to anything, but its ancestors sure as heck did. And it's not as though all dogs have taken the last few centuries off. They still work plenty hard for people, especially in New York City.

Back in the 1930s, two Scotch collies, Mike and his son, King, patrolled Prospect Park's flock of sheep. The *New York Times* wrote that they could often be seen "nipping the heels of laggards on the morning drive, rounding up strays, and repelling the attacks of Brooklyn dogs."

The NYPD also employs dogs. Canines have been on the beat since 1907, when Lieutenant George Wakefield traveled to Belgium and returned with five police dogs. Currently, the NYPD keeps around a dozen counterterrorism dogs on staff. These dogs sniff for bombs and explosives in public places. Arguably, these pups, who are named for fallen police officers, keep millions of New Yorkers safe.

In the aftermath of the September 11, 2001, attacks, three hundred search-and-rescue (SAR) dogs, including Cowboy, Trakr, and Riley, were deployed to find survivors and remains. More dogs returned to the neighborhood in the following months to act as therapy dogs. Years later, in 2011, Cairo, a Belgian Malinois, accompanied US Navy SEAL Team Six when they raided Osama bin Laden's compound in Pakistan. That good boy put his life on the line to avenge the September 11 attacks on Lower Manhattan. Any New Yorkers who dislike dogs should maybe never forget that.

The much more pedestrian and common version of service dog is the seeing-eye variety, those especially good dogs who help the blind cross the street and generally get around town. Imagine being blind in Midtown at rush hour: the noise, the crowds, the danger. The fact that a seeing-eye dog can do its dog job in Manhattan, undistracted by selfie-taking tourists and delicious smells, is truly incredible.

The Seeing Eye guide dog school in Morristown, New Jersey, the oldest in the country, won't graduate any of their pups until they can make it past

the hurdle that is Manhattan. If those dogs, which are usually Labrador retrievers, can make it there, they truly can make it anywhere.

In light of their seemingly unending service to humanity, it's a shame any dog anywhere should suffer. Though, sadly, so many do.

Incidentally, the most obvious thing New Yorkers can do to help dogs is to stop purchasing them (or, as they say on social media, "Adopt, don't shop"). There are so many unwanted dogs living in shelters, and rescuing a shelter dog can literally mean the difference between that pup's life and death.

In New York City, many of the rescue dogs come from the southern United States, where spay and neuter rates are low and kill rates are high. Local shelters such as Badass Brooklyn Animal Rescue and North Shore Animal League relocate thousands of dogs from kill shelters to homes in the city. Ladybug, a pit bull mix living in a happy home in Brooklyn Heights, was one of those dogs. She came to the city from Georgia afraid and pregnant, but now spends most mornings off leash at Cadman Plaza in Brooklyn. For a few early hours every day, she is free to zoom and boop around with Hugo, Buddy, Sampson, and all the other goofy dogs. True to form, this routine also benefits the humans, who get fresh air, some exercise, and a bit of early morning socializing. This congregation is not unique to Brooklyn. There are similar pockets of happy morning magic that happen all over the city. And beyond the dog parks, there are hundreds and thousands of dogs in all five boroughs improving the lives of countless New Yorkers in both big and small ways.

These dogs aren't asking for much, just a happy home, an end to abject cruelty and institutionalized neglect, and maybe some treats and belly rubs every once in a while. People really should do more for dogs if only because there seems to be no end to what dogs would do for people.

Latin Name	Collective Noun
Apis mellifera	a swarm of bees

Honeybees

In 2015, the largest known marijuana-growing facility in New York City's history was discovered by honeybees, which were drawn to large vats of maraschino cherry juice left unattended at the Dell's Maraschino Cherries factory in Red Hook, Brooklyn, the front for the operation. These bees, and the cherry-red honey they made, ultimately led environmental inspectors to investigate the facility, which led to warrants from the US Drug Enforcement Administration and what the *New York Times* headlined "The Fall of the Cherry King." It's a crazy story, and one that might never have come to light if not for the bees.

This was an unintentional sting job. Bees can't be trained, not even by cops. Instead, bees do what bees do, which is collect an easy-to-find sweet thing and turn it into honey for the good of the hive. They are just as happy with fields of organic flowers as they are with vats of cherry syrup.

The bees that ratted out the Red Hook weed growers were neighborhood rooftop bees kept by a local chef, a more common fixture since the 2010 repeal of then-mayor Rudy Giuliani's beekeeping prohibition. Today, cops only get involved with bees when they swarm, which occurs whenever a beehive collectively decides to split up and create a new colony. It's a fascinating display of how bees function as a eusocial superorganism. But in a crowded place like New York City, it can also be a problem.

Thankfully, the NYPD has a few bee cops in their ranks, including Officer Michael Lauriano. With his mustache and close haircut, Lauriano looks the way a New York City cop might be portrayed on television. Only instead of the standard NYPD blue uniform, he wears a white shirt (long sleeved, of course) to better see the bees buzzing around him. When a new swarm is reported, Lauriano is called. High up on a ladder, with an improvised vacuum, he is cool as can be, hoovering up thousands of presumably very angry bees.

Andrew Coté is called if ever a bee cop can't be summoned. Coté is a fourth-generation beekeeper, and it's been his full-time job since 2003. He has around five hundred hives in his keep, which makes him among the city's most prolific beekeepers. All those bees can produce up to twenty-five thousand pounds of honey per year. Coté has also received "thousands" of stings from angry bees. After all, beekeepers don't make honey—they steal it.

During the summer months, Coté says there can be as many as five swarm calls a day, and the swarms can occur anywhere. In 2017, Coté and two assistants removed a swarm that landed four hundred feet above Times Square. A few years earlier, in 2015, a swarm found its way to some unlucky guy's locked-up bike on West Fifty-Sixth Street.

Coté keeps his own bees all over town, including on the roofs of the United Nations and the Waldorf Astoria, among other locations. Much of the honey he sells every Wednesday in Union Square bears a label indicating the location of where it was made, such as the High Line, Bushwick, and Da Bronx. Each varietal has its own delicious flavor, its own local culinary story to tell.

When he's not responding to swarms, tending to his bees, or selling their honey, Coté can be found teaching classes to the New York City Beekeepers Association. During the sessions, which sell out weeks in advance, the aspiring beekeepers sit attentively, each with a notepad and dog-eared copy of *Beekeeping for Dummies*.

The classes are fascinating. For example, two bees left alone won't reproduce. Hives are over 99 percent female, though only the queen can bear offspring. At her prime, she lays around two thousand eggs a day. These eggs ideally will have been fertilized by male drones from different hives who die in the process. And when a queen begins to falter in her egg laying ability, nurse bees will begin producing a replacement queen right under her nose. To do so, a dozen eggs are set aside and fed an exclusive diet of royal jelly, which the nurse bees produce from glands in their heads. When a new queen emerges, she immediately kills the other hatchlings with her stinger—queens are the only bees that can sting more than once—before setting out to fight the sitting queen bee to the death.

Hive politics aside, beekeeping is a lot of work. It requires constant hive checks. Beekeepers even must contend with the mood of their bees who don't necessarily love it when a human dressed as an astronaut comes to steal their honey. According to Geraldine Simonis, head beekeeper at Brooklyn Grange, a rooftop farm operation, varroa mites, which can lead to colony collapse, are also a major problem.

Protecting bee populations against colony collapse—any threat really—is critical. A loss of bees doesn't just mean no honey. It also means no cucumbers, no strawberries, no natural pollination, no nothing. As Simonis puts it, "Bees are important only if we want to keep eating food." Brooklyn Grange is able to grow a lot of food, thanks in large part to its thirty-one beehives. They currently grow more than eighty thousand pounds of produce per year from their five acres across three rooftops in Brooklyn and Queens.

Rooftop farms and gardens are crucial because they capture and reuse rainwater otherwise destined to overburden the city's infrastructure. The soil also absorbs heat better than a standard tar roof, thereby mitigating the urban island heat effect. Above all else, these gardens produce food that doesn't need to be delivered to the city via gas-guzzling truck. In return, all these green spaces require is an empty roof, a bit of topsoil, a willing community, and, of course, some bees.

Latin Name	Collective Noun
Equus caballus	a team of horses

Horses

For centuries, New York City ran on literal horsepower. All ground transportation, everyone and everything, was moved by horses, and lots of them. In the 1880s, there were over 150,000 horses living in Manhattan, about one horse for every ten people, a number that was equal to Pittsburgh's human population at the time.

Horsecars were the most common mode of transportation. These ubiquitous trolleys sat twenty human passengers and were pulled by teams of two horses. The service ran sixteen hours a day and, since a horse could only work four hours at a time, required at least eight animals to operate. Horses moved a lot of the city's freight too. In the Meatpacking District, a team of horses famously manned by the West Side Cowboys directed train traffic on Tenth Avenue.

Not surprisingly, all these horses left behind a lot of waste, which posed its own nagging problem for the city: an average horse made around twenty-five pounds of waste a day to go with about a quart of urine. There was briefly a demand for the manure, but eventually that market crapped out with oversaturation. So more often than not, the horse business was left along its route. It made for a pretty disgusting streetscape, which became even more hellish with rain or summer heat. There is some suggestion

that New York City's iconic stoops were actually created as a way to keep people's front doors above and away from the overwhelming amount of manure in the streets.

When these hardworking horses weren't shitting curbside, they were dying of overwork. A streetcar horse had a life expectancy of only two years, which meant a lot of dead horses. In the year 1880 alone, New York City removed fifteen thousand dead horses from its streets, though a good many were left to simply rot in the street and inevitably spread disease.

The ones the city did collect were sent to be rendered in places like Barren Island, a former island that sat off the shore of southeastern Brooklyn at the mouth of Jamaica Bay. It received trash and dead animals from all over the city. The island was home to about fifteen hundred people, one small schoolhouse, and four saloons. With a dozen horse-rendering plants dotting the shoreline, the adjacent body of water came to be known as Dead Horse Bay. Whatever parts of the horse could not be recycled into glue, buttons, or other useful items were simply dumped into the water.

By the turn of the twentieth century, automobiles phased out the city's need for horses and therefore its need for horse-rendering plants. Local Brooklyn neighborhoods rejoiced when

plans were set in motion to consolidate the city's landfills at a remote site in Staten Island called Fresh Kills. Decades of boiling dead horses would finally be reined in too.

Eventually, Robert Moses, the legendary parks commissioner and "master builder," would get his hands on Barren Island and radically transform it. First, he reinforced it with thousands of tons of sand from nearby Jamaica Bay, and then he connected the island to Brooklyn with landfill and repurposed it as the city's first municipal airport, Floyd Bennett Field. Next, he built the Marine Parkway Bridge, which extended south from the former landfill, linking southern Brooklyn to the Rockaway Peninsula in Queens. The western edge of the site was then designated for landfill.

Moses loved to do this sort of thing in New York City, specifically: stashing trash in a way that would transform marshy, low-lying land into something more useful. But what makes this landfill noteworthy is that it actually burst open in the 1950s and has been depositing trash into nearby Dead Horse Bay ever since. Any kind of storm or inclement weather speeds up the contamination, and everyday erosion accomplishes the rest.

Unofficially, the area is now called Glass Bottle Beach. There are other bits of household garbage there, even some horse bones, but most of it is old glass. There's something oddly beautiful about it all, the waters of Dead Horse Bay steadily coaxing the trash out of the busted landfill before tossing it back onto the shore with every wave. There's an audible, almost melodic quality to it, as though a metronome were paired with wind chimes.

Today, the beach, bay, and former airfield are all part of the greater Gateway National Recreation Area. The National Park Service manages the site and views the trash, even the really pretty pieces of glass, as historical artifacts and insists people leave them be. There's less demand for all the horse bones that wash up, but those are off-limits too. It's maybe ironic to outlaw the pickup of garbage, but this is an odd situation and those are the rules. Instead, beachgoers are encouraged to walk among the unbridled trash of New York City's past, the remains of how things used to be.

Latin Name	Collective Noun
Ovis aries	a flock of sheep

Sheep

St. Patrick's Cathedral, the original one south of Houston Street, opened its doors in 1815. Previously, the area around the church had been farmland, as had been most of Manhattan. As the city grew, however, it became increasingly difficult for Manhattan farmers to keep their pigs, cows, and sheep. Incidentally, the city's rapid urbanization eventually led to the creation of Central Park in 1858, a green ward, lungs for the city. It was a manufactured sylvan oasis, meant to replicate the natural order that so recently had been displaced by the city's growth.

Central Park was an instant success, and initially, sheep were given a chance to remain in Manhattan as its groundskeepers. (The other farm animals, particularly the pigs, had to go.) For over fifty years, sheep roamed Central Park, specifically in the appropriately named Sheep Meadow. Out in Brooklyn, Prospect Park had sheep too.

The sight of sheep and honest-to-god shepherds, along with their dogs, cast a pastoral spell over the otherwise crowded and usually polluted city. Plus, they kept the lawns cut and fertilized naturally.

Central Park's sheep were eventually evicted in 1934 by Robert Moses, the legendary parks commissioner and "master builder," who, through the creation of public authorities, wielded incredible power in New York City for nearly half a century, despite never actually being elected to any office. Moses was famously indifferent to the humans he displaced and relocated all around the city. It stands to reason he showed equal concern for the opinions of the livestock he uprooted. The Manhattan sheep were not slaughtered; instead, they were relocated to Brooklyn where they were joined with the Prospect Park flock. But this arrangement didn't last long. The next year, this newly combined Brooklyn flock would be removed from its park, for reasons not entirely clear. There's some suggestion that the cash-strapped city couldn't maintain a flock of sheep during the Depression. Another theory says that park officials feared the sheep would be captured and eaten by hungry and desperate Brooklynites. In any event, like so many pet dogs, the landscaping sheep were moved to a farm upstate to live happily ever after. Or that's the story, anyway.

Either way, the sheep went away. The country went off to war, and afterward, its cities, most notably New York, generally went to shit. By the 1970s, it was hard to imagine sheep ever having lived in the city's parks, because it was hard to imagine *anything* living there.

Happily, all that has changed. New Yorkers stood up for their parks, and as a result, the

city and its open spaces have never been better (though the sheep have still not been hired back by the Parks Department).

Sheep have found part-time employment, however, back down in SoHo, on the former farmland that became the first St. Patrick's Cathedral. They come for about two months every summer, usually in August and September, right around the Feast of San Gennaro. They eat the grass in the graveyard, delight the neighborhood, and act as a tidy physical metaphor for the church's very own Jesus Christ, aka the Lamb of God.

in charge of making sure the motion-activated lights and alarm system are functioning so that the sheep are safe from overly interested neighbors. He also handles all the paperwork and permits. "The New York City Department of Health does not allow this to be a petting zoo. [The sheep] are safely behind a barrier so no one can go in and touch them," says Alfieri. "And they just graze. And they get their pictures taken a lot."

The sheep may never wander into the cathedral, but they certainly do find their way into the sermons, especially during the two months when

"

When the sheep came, we got not one negative comment about it.

"

The comeback of the landscaping livestock was made possible by another New York City tradition: busting balls. In the early 2010s, a groundskeeper at the church supposedly asked the monsignor, "What are you gonna do when I retire?," to which the monsignor replied that he might hire sheep, which, he jokingly wagered, would do a better job.

The joke must have seemed like a good idea, because ever since 2014 the sheep have found their way back to SoHo every summer. Frank Alfieri, cemetery director, is in charge of the visiting-sheep program. It's a lot of work: he's

they are just outside, grazing in the cemetery. As Alfieri likes to point out, sheep are already the most frequently mentioned animals in the Bible. What's probably most remarkable about the SoHo sheep is that none of the neighbors seem to mind.

"You know, I got to tell you, it's interesting: In the city, you always get complaints. You get complaints if the church bells ring," says Alfieri. "But when the sheep came, we got not one negative comment about it. Rather there's an expectation that they're going to be here. It adds a very bucolic element to this urban environment."

Latin Name	Collective Noun
Sus scrofa domesticus	a drift of pigs

Pigs

In the summer of 1859, New York City declared war on its pigs, evicting every putrid pigsty and pen in Hogtown, or what is now roughly the area between Times Square and Central Park South. This forgotten real estate battle, however, was just one minor act in a larger-scale urban transformation that would rapidly and irrevocably change Manhattan forever.

It may be hard to believe, but New Yorkers once lived off the land, even in Manhattan. As recently as the early 1800s, the island metropolis provided everything its residents needed: people fished in now-buried streams and ponds, they had farms stretching across entire modern-day neighborhoods, and many kept animals.

Pigs were among the best animals to keep. They reproduced rapidly and cost relatively little, if anything, to feed. Rather intelligent little critters, a pig could be let loose in the morning to forage for its own food and would know to return to its pen each night. A poor Manhattan family could be sustained both economically and nutritionally on just a handful of domesticated pigs. According to Catherine McNeur's *Taming Manhattan*, there were approximately twenty thousand hogs living in Manhattan in the early 1800s, or about one pig for every five people.

Pigs also served as a de facto sanitation department for the city, eating up all the fish guts and other discarded foodstuffs left in the street. A pig could turn garbage into protein. Some pig farmers went a step further and fed their pigs offal, the boiled by-product of unused meat and decomposing bones and carcasses, which, while definitely disgusting, was also quite cost-effective.

Even in the best of circumstances, these little piggies made horrible neighbors, most of all because these piggery operations smelled awful. At worst, piggeries were feared to spread disease in a city already in constant fear of typhoid or cholera outbreaks.

As the city continued to grow outward from its original Dutch outpost way downtown, it pushed the piggeries and other rural farming enterprises farther and farther uptown. Bearing down on the piggies from the north was the recently opened Central Park. The downtown aristocracy heading uptown to see the new green space had to suffer first through Hogtown. An 1859 article from the *New York Times* describes how "it has become customary for the conductors of cars as they approached the region of the pens to close the windows and give the signal to the driver to make the fastest time possible until he had passed through it."

The pigs had to go. On July 25, 1859, the city finally sent in an army of city inspectors

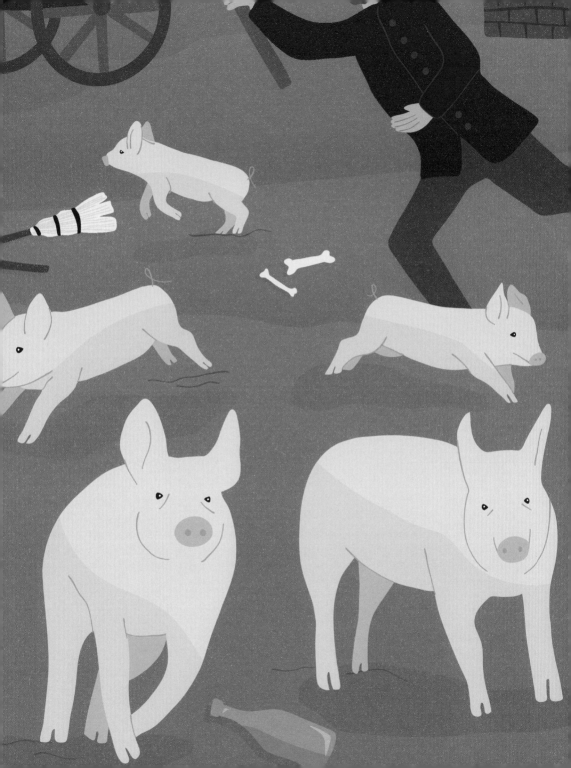

and police officers, who marched in separate columns through the heart of Hogtown. Most piggery owners had read the eviction notices and had already packed up and left. However, one piggery proprietor, James McCormick, promised to go down fighting, vowing "that he would shoot the first man that touched his hogs."

Apparently, McCormick was all talk, and the greatest ruckus in the "Piggery War" of 1859 just ended up being the squealing slippery pigs evading members of the city task force to great comic

demolished, and one hundred offal boilers were removed. The farmers relocated to Brooklyn, New Jersey, and other places where New Yorkers wouldn't have to see or smell how their food originated.

Indeed, the pigs were one of the last stank vestiges of New Yorkers' attachment to the land. Their removal was among the first of many instances of moving the dirty work of life, such as food production and later waste management, away from the city center and out of sight.

> **"**
> # Indeed, the pigs were one of the last stank vestiges of New Yorkers' attachment to the land.
> **"**

effect. The *Times* summed up the affair with just a sprinkling of anti-Irish sentiment included: "Here, as at the other places, the officers of the law entered, and amid the barking of dogs, the jabbering of Hibernian females, the noise of falling rubbish and the grunting and squeaking of swine, plied their pickaxes and crowbars, scattered the disinfecting agent by the pailful, and drove out the pigs."

In the end, nine thousand hogs were sent to the pound, three thousand pens were

Today, the former Hogtown neighborhood is known as Billionaire's Row, where glass-and-steel towers rise higher and higher above Midtown. It's a quasi-gated community in the sky, where the world's elite super rich have elbowed their way into the neighborhood and gobbled up listings with their all-cash offers. In fact, the demand for luxury condominiums is so high that these new buildings are literally casting shadows over old Central Park, not to mention hogging up the whole neighborhood.

Latin Name	Collective Noun
Crassostrea virginica	a bed of oysters

Oysters

Oysters are one of New York Harbor's best shots at clean water, as well as one of its best defenses from future storm surges. These are the same oysters New Yorkers have done their best to decimate with centuries of pollution and overconsumption. The oysters hold no grudge, however, and have returned to help restore the harbor, even if the city probably doesn't deserve it.

Way back in 1609, when Henry Hudson sailed into New York City, he happened upon one of the world's most impressive natural harbors, which held 220,000 acres of oyster beds below the surface on the harbor floor—nearly half the oysters in the entire world.

The ensuing wave of European visitors to Manhattan were introduced to eating oysters by the local Lenape, who would open the shells by wrapping the entire oyster in seaweed before tossing it on a fire. The new Europeans loved the tasty bivalves, and oysters quickly became synonymous with New York City, as Mark Kurlansky's brilliant book, *The Big Oyster*, skillfully outlines. Yes, long before hot dog and halal carts could be found everywhere, oysters were the city's ubiquitous fare, the original street meat.

Everyone in New York ate oysters. The rich saw them as a delicacy, and the poor enjoyed how cheap and easy to collect they were. Oyster taverns popped up all over the city to feed the seemingly insatiable appetite. The Canal Street plan, a popular oyster option, offered nineteenth-century diners unlimited oysters for six cents.

Of course, this pace could not endure, and soon the oyster population faced a multipronged existential threat. First, to feed too many people eating too many oysters, they were overharvested. By 1820, the oyster beds around Staten Island were depleted. Undeterred by this harbinger of things to come, New York began to harvest oysters at an even greater rate. By the early 1900s, over one billion a year were being pulled out of the area's waterways, which, even in this oyster-rich area, was not sustainable.

Another major threat to the oyster beds was the city's changing shoreline. Once an ideal oyster habitat of marshy, rocky shallows, it was soon replaced with a nearly unbroken string of bulkheads, piers, and landfill. It was good for real estate, shipping, and commerce, but bad for marine biodiversity.

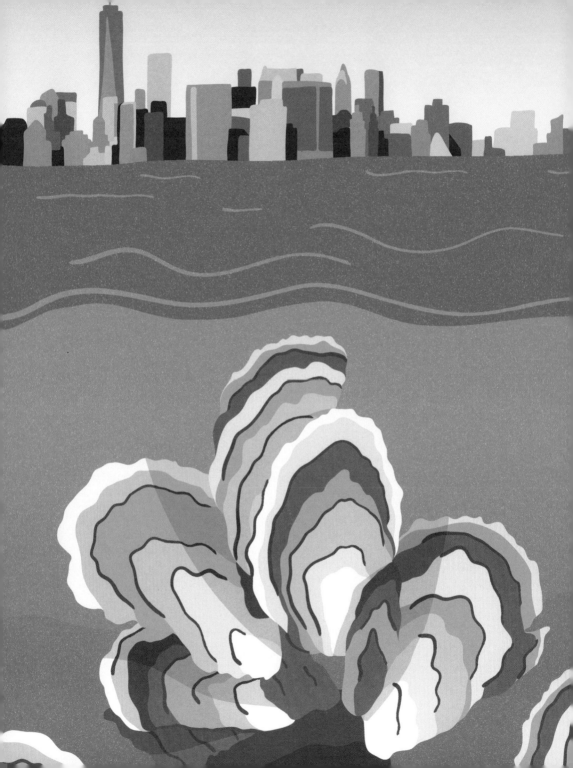

Lastly, waste management, or the lack thereof, dealt a devastating and final blow to city oysters. Until shockingly recently, in the 1980s, New York City was dumping millions of gallons of raw, untreated sewage into the harbor *every day*. Not surprisingly, this was bad for oyster beds. Back in 1921, the New York City Health Department was forced to close the Jamaica Bay oyster beds, out of which some 80 million oysters a year were harvested, due to fears of foodborne illnesses, including typhoid. From there, the end came fast, and six years later, in 1927, the last city oyster bed, in Raritan Bay, was closed.

New Yorkers stopped eating their oysters then, but it would take another half century, until the passage of the Clean Water Act in 1972, for the harbor to be given respite from pollution. By then, it was too little, too late. New York City oysters would survive as a species, but they would not be fit to eat again ever.

And just like that, New York City squandered one of its greatest natural resources. That's the thing about oysters: they reflect their surroundings. If people living near them are reckless with their environment, then it will show up in the oysters. Their typhoid-laden meat was simply a manifestation of New York's ecological sins.

Truly, New York's history with oysters is one of neglect and foolishness. But looking to the future, New York would do well to make amends with the oyster, given all the oyster could do for New York.

Figuratively speaking, New York City was made with oysters insofar as they provided a cheap and abundant food source. But in addition, parts of New York City are in fact constructed with oyster shells, including the lime used in

Trinity Church on Wall Street. Nearby, Pearl Street is named for the piles of oyster shells left there by the Lenape.

In Tottenville, Staten Island, a wholly different kind of oyster structure is being considered for the future. SCAPE Landscape Architecture has introduced Living Breakwater, a proposed series of oyster walls reinforced with concrete—essentially sea walls created from oyster reefs that can bear the brunt of storm surges and rising sea levels—to be built just past Staten Island's southern shore, an area particularly beat up during Hurricane Sandy in 2012. Gena Wirth of SCAPE told DNAinfo in a 2014 interview that the oyster walls could "reduce water velocity, reduce erosion of the shoreline, and reduce the height and intensity of waves." Tottenville, which once dubbed itself as "the town oysters built," is now wagering that its town's best shot at survival is to build its oyster reefs back up.

Also betting big on oysters is the Billion Oyster Project, a modest enterprise with huge ambitions. As the name suggests, its mission is to restore one billion oysters to New York Harbor by 2035. Oysters act as a keystone species, attracting other marine life to live around them, from microscopic organisms to crabs and fish. But of all the things oysters can do, their most amazing ability is cleaning the waters in which they live. These tiny beasts of burden are capable of filtering up to an extraordinary fifty gallons of water per oyster per day.

Billion Oyster Project got its name from some back-of-the-envelope math: if one billion oysters each filter fifty gallons of water a day, that could completely clean the water in New York Harbor every three days. The calculations

may be imprecise, but it's certainly worth a shot. Since launching in 2014, they have planted over thirty million oysters across five reef sites, including right off the coast of Governors Island and at the mouth of the Bronx River.

Billion Oyster Project is affiliated with the New York Harbor School. Their shared facility on Governors Island offers city kids hands-on experience with oyster monitoring and reef restoration. On weekdays throughout the warmer months, students with maritime ambitions, and maybe

allowing the spat to safely find a shell surface to call home. In this way, oysters live like human New Yorkers: in crowded clusters, often on top of one another.

It's a truly ambitious mission. But according to Sam Janis of Billion Oyster Project, getting the job done will realistically call for trillions of oysters, not just a billion. "In some ways, New York Harbor is unrestorable. I mean, not restorable by our own hand. Nature has its own course," says Janis. "However, compared to fifty

> **66**
>
> # Of all the things oysters can do, their most amazing ability is cleaning the waters in which they live.
>
> **99**

a few with community service hours to fulfill, ferry out to Governors Island to help construct gabions, a rebar-reinforced structure (think of them as oyster condominiums) that will eventually be filled with oyster shells.

The shells are donated by restaurants from all over the city, which not only aids the project but also diverts about eight hundred thousand pounds of waste from ending up in a landfill every year. Oyster larvae are then introduced to these oyster condos in the Harbor School,

years ago, there is a lot of life in the harbor. Many magnitudes more biodiversity and bioproductivity. No longer dumping millions of gallons of raw sewage into the harbor every day can do that."

So even though it remains a long shot, the oysters are down there below the surface working tirelessly for the benefit of New York Harbor. They are greatly outnumbered for the job, sure, yet still determined to leave the water a lot cleaner than they found it, a lot cleaner than New Yorkers left it.

4

The Returned

Animals that were once hunted, poisoned, and driven to the brink of extinction, that were written off long ago, never expected to be heard from again, have against all odds returned to a much greener city than the one they left. Their homecoming is a vindication, proof that environmental activism works. These animals are visions of New York City's past, yet their return paints a reassuring portrait for its future.

Latin Name	Collective Noun
Castor canadensis	a colony of beavers

Beavers

The beaver is the most important animal in New York City history, and tributes to these industrious little critters can be seen all over town: the city flag has two tiny beavers; in Lower Manhattan, Beaver Street is one of the city's oldest thoroughfares; dozens of beavers are carved into the walls of the Astor Place station on the number 6 line. What's probably most surprising, however, is that real-life beavers can actually be seen in New York City—specifically on the Bronx River, usually around sunset—paddling around, doing their dam thing.

Although they were once here in abundance, beavers were driven away for two hundred years because of pollution and overtrapping. But it took only two beavers, José and Justin, to usher in a new era for these creatures. Their return is a testament to the city's environmental improvements and a high-water mark for the remediation efforts of the Bronx River Alliance, an organization committed to cleaning the city's only freshwater river.

As far back as the 1630s, New York was influencing the global fashion industry by way of beavers. In *The Island at the Center of the World*, Russell Shorto writes that "the fur trade was the colony's [New York's] entire reason for being" and describes beaver-made felt as a "status-symbol-cum-necessity throughout Europe." By the late 1600s, according to *Science Daily*, more than eighty thousand beaver skins were exported annually from North America, often through Manhattan. According to Jim Sterba's *Nature Wars*, "the beaver became America's first commodity animal. Beaver pelts became a currency. Trade in them created an economic network that spanned the Atlantic Ocean for 300 years." This was bad for beavers but great for business. It was particularly great for John Jacob Astor, who would eventually be known as the richest man in America thanks to a fortune he originally made from trapping. In the 1830s, perhaps sensing things to come, Astor divested entirely from the beaver game and moved into real estate. Soon the rest of the city would follow, transitioning from a tangible economy based on natural resources to one that was more abstract and speculative.

According to Linda Cox of the Bronx River Alliance, the overzealous trappers were only part of the problem. The Bronx River, once a haven for beavers, was facing its own ecological demise. Like a lot of waterways during that time period, it had served as an open sewer, lined with mills and tanneries with zero environmental regulations. Even if local beavers had somehow been able to survive the market demands of the felt trade, they would not necessarily have found a suitable habitat elsewhere in the city.

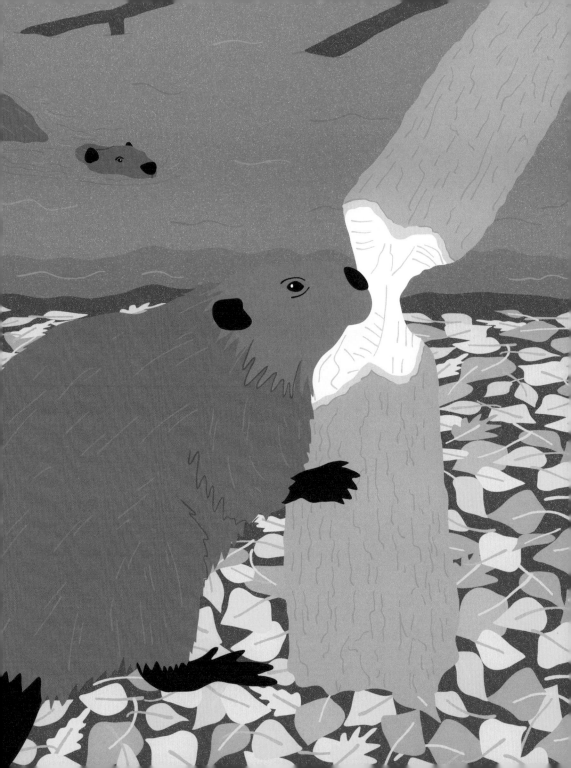

Efforts to restore the river, which runs twenty-three miles from Westchester County down to Long Island Sound, began in 1888 when land was set aside for Bronx Park, which is now home to the New York Botanical Garden and the adjacent Bronx Zoo. A subsequent solution for restoring the river came in 1908 when the Bronx River Parkway, a first-of-its-kind project, began construction. It may sound counterintuitive now to attempt cleaning a river by building a highway alongside it, but at the time it was seen as a revolutionary development in recreational land use.

York City, was reaching its nadir, and to many people the thought of restoring the Bronx River, was at best, a quixotic notion."

Slowly but surely, though, small signs of progress began to show, and in 2008 the craziest thing happened: a beaver was spotted in the Bronx River, the first New York City beaver in more than two hundred years. He was the buck-toothed vindication of decades of hard work and environmental activism.

He was also good for the river. Beavers are a keystone species: their dams raise water levels,

> **66**
>
> ## He was the buck-toothed vindication of decades of hard work and environmental activism.
>
> **99**

Most important, the project included an actual sewer pipe to divert waste away from the river.

In 1974, a new wave of remediation efforts began, spearheaded by Ruth Anderberg and her organization, Bronx River Restoration, which in 2001 would morph into the present-day Bronx River Alliance. The cleanup was no easy job. Sure, the river was no longer an open sewer, but it was still a de facto dump. In *The Bronx River in History and Folklore*, Stephen P. DeVillo describes a city on the brink of environmental ruin by way of the river. "The Bronx, along with the rest of New

which leads to additional plant growth, which attracts insects, which feed fish, amphibians, reptiles, and birds. In other words, beavers make the whole damn ecosystem go round.

Shortly after the sighting, it was decided the prodigal Bronx beaver should be named José, in honor of US representative José Serrano of New York's Fifteenth Congressional District, a tireless champion of the river's remediation. In a statement found on his website, he says, "If a beaver chooses to live in our river, we are succeeding in our goal of restoring a wildlife-friendly waterway."

Two years later, in 2010, a second beaver was spotted on the Bronx River. This time, the naming was put to a vote, and by an overwhelming majority, the name Justin was selected in honor of Canadian pop star Justin Bieber.

According to Cox, José and Justin most likely came to New York City by way of Westchester County or Connecticut, a migration pattern from the suburbs to the big city that is similar to those of many Millennial humans. "It's not so amazing that beavers headed here," she says. "It's more amazing that when they headed here, it worked out." She is quick to point out that while a population of two beavers is small, it still qualifies as a "thriving" one. Their return is just one example of the Bronx River Alliance's success in saving the once-blighted waterway. Fish and birds have also returned. An American mink has even been spotted.

As a way to showcase this winding ribbon of returned wildlife, the Bronx River Alliance hosts an annual flotilla, in which dozens of boats, canoes, and other buoyant vessels travel down the river together as a floating party. On other warm weekends, they offer guided canoe tours, which run for a couple of hours, usually on Saturday mornings.

One of the popular tour launch points is Shoelace Park, an aptly named string of parkland alongside the river, north of the botanical garden, east of Woodlawn Cemetery, and about two blocks west from the 219th Street subway station. Canoes, paddles, and life vests are provided as part of the tour. Those without a friend are paired up, and after a brief refresher on safety, it's time to paddle.

Before long, the hum of street noise fades as the river approaches the Bronx River Forest, one of the few truly untouched sections of New York City. From there, the canoes drift through the botanical garden and eventually the Bronx Zoo.

The river is still not perfectly clean—there are still a few car tires and empty beer cans to be found. Even the occasional condom will float by or, as it's affectionately called on the canoe tours, "a Bronx jellyfish." For the most part, though, the river is serene and full of life coursing along the way. It's an incredible experience. At times, it's hard to believe it's the Bronx.

"People sometimes think that natural areas in New York City are pretend natural areas. They're not really natural areas. They might say: 'This isn't really a river,'" says Cox. "Well, it is real! It really operates like a river. It really has lots of species of fish in it. It has lots of birds along it. It has the beavers too. . . . Yes, it's real!"

There is no guarantee of seeing a beaver on the canoe tour, but still, the experience of communing with nature in the very middle of the Bronx, after decades of neglect, is pretty eye opening.

Latin Name	Collective Noun
Ammodramus savannarum	a crew of grasshopper sparrows

Grasshopper Sparrows

Grasshopper sparrows are hard to spot—that's by design. They are little birds with oversize heads that don't really fly so much as run among the camouflage of high grass. Grasshopper sparrows are, however, easy to hear. In fact, they get their name from a distinct song that sounds almost like a buzzing insect. Oh, and they also eat grasshoppers.

Another reason these birds are so hard to see is because their numbers have dwindled due to environmental factors. With ever-expanding suburbanization throughout the Northeast, their habitats have been encroached upon, steadily decreasing their populations for decades. These birds, like a lot of grassland species, had been effectively forced out of the area, unable to keep up with the rapidly changing city life.

The grasshopper sparrow is a threatened species. According to the North American Breeding Bird Survey, the number of grasshopper sparrows in New York State declined 97 percent since the 1960s. On Staten Island, however, the little birds have staked a somewhat surprising comeback, and in a very unlikely place.

The state's largest colony of grasshopper sparrows makes its home at Freshkills Park, a twenty-two-hundred-acre space not yet completely open to the public. Freshkills Park is on the western shore of Staten Island, just across the Arthur Kill waterway from New Jersey. Older New Yorkers may know the park better by its old name, the Fresh Kills landfill. Where thirty thousand tons of New York City trash were once dumped daily is today transforming into a sprawling and serene open space nearly three times the size of Central Park.

Before it was landfill, the area comprised tidal creeks and marshlands with incredible biodiversity. To land-hungry New Yorkers, however, it was wasted space. Robert Moses, the legendary and controversial parks commissioner, decided to fill the marshes in with the city's garbage.

Trash has always been a problem for New York City, a fetid check on its otherwise unrestrained growth. Fresh Kills landfill promised to ease some of that burden while simultaneously providing the city with usable land. It was probably a no-brainer at the time.

Prior to landfills like Fresh Kills, pigs would eat garbage left in the city streets. Later, trash was often burned and hauled to places like the present-day Flushing Meadows area of Queens. Other times, garbage was just hauled out to sea and dumped there.

When the Fresh Kills landfill opened in 1948, it was billed as a temporary solution meant to last only a few years. But the garbage kept coming. By 1955, it was officially the largest dump in the world, and by the end of the 1960s the site was receiving half of New York City's garbage, which was delivered by barges and piled on four major mounds. At some points, these garbage mountains were taller than the Statue of Liberty.

Suffice to say there were no grasshopper sparrows then. There was not much of anything wild, with the exception of seagulls and rats, of which there were a lot. It was a pungent and toxic hellscape.

In 1970, then sanitation commissioner Samuel Kearing visited the site and remarked, "It had a certain nightmare quality. Fresh Kills had for thousands of years been a magnificent, teeming, literally life-enhancing tidal marsh. And in just twenty-five years, it was gone, buried under millions of tons of New York City's refuse."

When it stopped receiving trash in 2001, it was the largest landfill in the world, rumored even to be visible from space. Ironically, though, ruining these wetlands with five decades of dumping unintentionally set it up well to be parkland. Trashing the place so spectacularly actually made the park project possible—if the dumping had stopped in the 1950s or 1960s, the land most likely would be developed into condos or strip malls. The grasshopper sparrows, that little bird nearly pushed to the brink of extinction, would not have this new habitat.

"It's never going to be fully restored to the marshland. We're not trying to mask over what this was. It's more trying to work with what's here and capitalize what we have," says Dr. Cait Field, science and research development manager at Freshkills Park. "The trash isn't going away. You can't take it anywhere. It's millions and millions of tons." So instead, the New York City Department of Sanitation has capped the trash with several layers of gravel, a lot of topsoil, and, most important, an impermeable liner to keep the trash in place. Today, every inch of land above sea level at Freshkills—even the smallest hill—is actually a covered-up pile of garbage.

Trees are hard to maintain at Freshkills. The roots can't go too deep before they penetrate the odorous core of garbage mountain. Tall grass does much better, which is welcome news for the grasshopper sparrow and other local critters who require this once abundant, now somewhat rare habitat. "There's a lot of species that have started to use this area," says Field. "It's the only large-scale grasslands available to them in the region."

Freshkills Park will be fully open, all twenty-two-hundred acres of it, by 2035. It will be a massive open space friendly to human and nonhuman species alike. Freshkills will also serve as a reminder that New York City cannot outrun or hide from its past. It cannot undo the mistakes of yesterday. But thanks to a little care and a whole lot of topsoil, the grasshopper sparrows and others are more than happy to make the most of that which humans had previously thrown away.

Latin Name	Collective Noun
Teredo navalis	undetermined

Shipworms

Decades of clean water initiatives in New York City brought back aquatic creatures such as oysters, whales, and countless fish. But it also brought back pests in the form of marine borers, destructive mollusks that have returned to the city's waters to eat the load-bearing timber pilings fortifying many of the expensive new waterfront parks. In a cruel twist, a cleaner marine environment has led to a time-consuming and costly hassle.

There are two species of marine borers that make their home in New York. One, the delightfully named gribble, is a diminutive crustacean that resembles a miniature shrimp. Gribbles are isopods and attack wood from the outside. The other is the shipworm. Shipworms are round and thin and can grow as long as a foot. Despite its name, the shipworm is not a worm but rather a mollusk, cousin to the happy clam. Unlike gribbles, shipworms eat wood from the inside out, often coming up through the mud line, meaning the full extent of damage cannot be seen until it is too late.

And similar to many New Yorkers with rent control, once a shipworm has burrowed into its habitat, it is there for life. "As long as they have wood, they will continue to grow," says Daniel Distel, a research professor at the Marine Science Center at Northeastern University. Distel is an expert on shipworms. He says their species has fossil specimens dating back sixty million years. And like most New Yorkers, their roots lie overseas with immigrant ancestors that hitched a ride across the Atlantic. It's said Christopher Columbus lost two ships to shipworms on his last voyage.

By the early decades of the nineteenth century, shipworms were a known nuisance. In *Gotham Unbound*, historian Ted Steinberg cites a city council document from 1833 that describes how the city's piers "generally endure only from 14 to 17 years before they are destroyed by worms."

But by the mid-1850s, they seem to have disappeared. In 1889, The *Brooklyn Daily Eagle* speculated that "the large discharge into the Wallabout Bay of foul matters from sewers, sugar refineries, and oil distilleries may have something to do with it."

It was shit luck, all right. But it worked. The destructive little critters had gone away.

The problem was that the toxic effluence also drove away whales, dolphins, fish, and pretty much all other marine life. New York's harbor was so polluted during this time that

ship captains playfully referred to it as a "clean harbor," meaning any barnacles, shipworms, or other nautical stowaways attached to a ship would be cleaned off with a quick sail through.

"Only one thing protects New York's vast longshore miles from the dreaded parasite—the harbor's pre-eminence as a polluted port," said the *New York Times* on July 26, 1936.

For better or worse, the Clean Water Act of 1972 changed everything for shipworms. By 1987, the city was treating 100 percent of its dry-weather wastewater flows. Additionally, the EPA compelled major polluters, such as General Electric, to kindly stop dumping PCBs into the Hudson River. The suddenly healthier harbor allowed fish, oysters, and whales to return. The marine borers also rebounded and found the much cleaner waters abundant with delectable timber piles.

What's crazy is that the shipworm problem went mostly unnoticed until December of 1995, eight years after the EPA regulations went into effect, when a seventy-foot section of wharf on the East River near Fourteenth Street collapsed, its underwater supports gnawed into submission. Divers investigating the collapse attributed the structural damage to marine borers. The incident nearly left Con Edison's nearby utility station as well as the FDR's northbound traffic underwater. It also put New York City on high alert: marine borers were back to feasting on the very foundations of the city's shoreline.

And that's a big problem, because New York City has more than five hundred miles of shoreline that increasingly holds expensive condominiums and beloved parkland. Brooklyn Bridge Park is one of those parks. About a third of the park's acreage sits on reclaimed piers that extend out into the East River and are supported by timber piles. Call it an existential threat or call it a shakedown. Either way, the park must pay up, and it won't be cheap.

According to David Lowin, executive vice president of Brooklyn Bridge Park, the cost of repairing and retrofitting the park's piers to be marine borer resilient, in a best-case scenario, could add one hundred fourteen million dollars in additional operating costs. To put that in context, the original cost to construct the park, according to Lowin, was four hundred million dollars.

To solve this, the park's eleven thousand timber piles will be coated in an epoxy that not only seals off the piers from invasion but also cuts off oxygen supply to any marine borers already living within the structures. It is an environmentally efficient solution that will allow the park to stay open while repairs are made.

Shipworms and gribbles may be annoying, and they surely are expensive, but this is the marine borers' turf, and humans are the invasive species. It's only fair people should have to pay a toll for encroaching on nature's territory.

Luckily, Brooklyn Bridge Park has a solution in place to pay for this. Unlike other city parks, Brooklyn Bridge Park dedicates about 8 percent of its footprint to revenue-generating entities, such as a massive hotel and condominiums. Some say this arrangement blurs the line between private business and public park. Others shout that they are literally blocking the neighborhood's cherished views of the Brooklyn Bridge. But ultimately, these buildings will fund shipworm maintenance and repairs for the park.

Whales

Paul Sieswerda used to jokingly call the whale-watching tours he led in New York Harbor "whale-watching adventure cruises." The real adventure was whether any whales would be spotted at all. Then things changed. Humpback whale sightings in New York City jumped tenfold from 2011 to 2016. Sieswerda, who eschewed retirement to create the nonprofit whale-watching advocacy group Gotham Whale in 2015, chalks up their resurgence to a combination of factors, including cleaner waters and more available food. "Prior to 2010, you only heard about very rare sightings," says Sieswerda, who was previously the curator of the New York Aquarium for more than twenty years. "If a whale had been seen before that, we would have heard about it."

The Gotham Whale tours sail on the *American Princess*. On board, Sieswerda is half emcee, half naturalist, handing out floppy specimens of whale baleen for guests to examine. Out on the water, however, he joins the guests in scoping out the horizon, hoping for humpbacks. And he's seen quite a few. By way of the whales' unique, fingerprint-like flukes, Sieswerda and his team have identified around one hundred fifty individual whales, which at least in total tonnage, is a lot of whale.

Sieswerda originally planned to spend his retirement "under a tree somewhere," where he could sit and write. But then he began hearing about humpback whale sightings. The scientist in Sieswerda stirred, and before long, Gotham Whale was born. To hear him tell it, he is working harder in retirement.

A crucial part of that work is coordinating citizen scientists, the additional eyes and ears he needs to get a fuller picture of New York City whales. Sieswerda has enlisted Flagship Brewery on Staten Island to give a free beer to anyone who produces an authentic sighting, which ideally includes a photograph of the whale's fluke and a rough sense of where it was seen. So far there have not been many takers. Sieswerda jokes, "It takes more than a free beer to get people out to Staten Island."

Truly, the most reliable way to see humpback whales in New York City is aboard the Gotham Whale tours. They sail from Riis Landing in Rockaway, Queens, every Wednesday through Sunday from May until November. The tours last a few hours and cost around $50, which Sieswerda refers to as "micro-grants" the customers are making to allow this kind of wildlife research to continue.

Typically, the humpback whales are spotted just past Breezy Point in the waters of the western New York Bight, which is essentially the far side of the Verrazzano Narrows. But many of these

massive maritime mammals have made cameos farther upstream and indeed farther uptown. In 2016, one curious humpback traveled as far up the Hudson River as the George Washington Bridge. In that same year, across town in the East River, a humpback whale was spotted near Gracie Mansion around Eighty-Fourth Street. What makes this East Side whale additionally noteworthy is that it most likely passed underneath the iconic Brooklyn Bridge to get upriver. Perhaps some lucky tourist even spotted the whale making its journey beneath that world-famous span. And just imagine subway passengers crossing under the river with a humpback whale above their heads.

Thanks to environmental victories, like the Clean Water Act of 1972, the whales and other marine animals in New York City waters have been given a new lease on life. An abundance of food sources, which are also now thriving in the cleaner waters, helps. Humpback whales love menhaden fish, whose numbers have swelled in recent years. Menhaden, also known as bunker or bait fish, won't be found on many menus.

66

Just imagine subway passengers crossing under the river with a humpback whale above their heads.

99

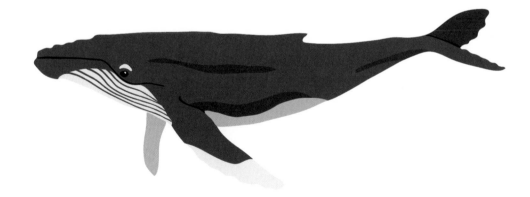

However, they are still fished on an industrial scale, most notably by Omega Protein of Houston, which processes the fish into fertilizer and omega-3 fish oil supplements.

In 2012, the Atlantic States Marine Fisheries Commission enacted a measure reducing the total allowable catch of menhaden. And while it may have upset the bulls of Wall Street, it has delighted the humpback whales, who have happily lunged in to gobble up the excess menhaden.

Sieswerda believes that whales can hear menhaden, specifically the sound of bubbles releasing behind the fish. It's called a fast and repetitive tick, or FART. It sounds silly, but Sieswerda contends that a review of menhaden anatomy needs to be done before it can be ruled out.

What's remarkable is that in years past, all these fart-sniffing whales would have bypassed New York City entirely and instead traveled up to Massachusetts, Maine, or Canada. They are now deciding to dine in New York City waters for a change. "They found a way to shorten their migration route and take advantage of the food here in New York," Sieswerda says. He also points out that the New York population skews young, which might mean that the younger whales are trying to avoid competition with more established populations up north by stopping here.

Sieswerda also suggests whales could be telling one another about the new local food scene. "They're well known to make noise and communicate to one another," he says. "One of those sounds could be, 'Wow, I just had a great meal here in New York!'" The research detailed in *The Cultural Lives of Whales and Dolphins* by Hal Whitehead and Luke Rendell supports the hypothesis that whales share information with one another. The authors depict these whale-to-whale communications as long, intricately complex songs with unique structures and repetition patterns. As incredible as it may sound, these whales may very well be singing the praises of New York Harbor to one another.

Oddly, the same cannot always be said for the humans of New York who, to Sieswerda's amazement, have not flocked out to sea with him to view these New York giants. Still, any adventurous New Yorker or visitor with four hours to spare can see whales crashing the waves just off the city's shoreline. The whales seem to love it there. They love the food so much that they're even telling all their friends about it. Hopefully more human New Yorkers will do the same.

Latin Name	Collective Noun
Falco peregrinus	a cast of falcons

Falcons

There are more peregrine falcons per square mile in New York City than in any other place in the world. Aiding these unexpected raptors is a team of local conservationists who work under dangerous conditions to keep falcon populations aloft. It's noble work carried out by truly dedicated people. But it's nothing compared to what was done decades earlier to keep these birds from going extinct in the first place.

Peregrine falcons in New York City predate the Dutch. Places like Palisades Park in New Jersey provided ideal habitats for their scrapes, which are not really nests but rather tiny impressions scratched out of cliffs where eggs can be laid. Tall buildings and towers throughout the city are easy urban stand-ins for cliffs, including One World Trade Center and the Manhattan tower of the George Washington Bridge, to name just a couple of the dozens of peregrine nest locations in the city.

The bright lights of New York City also benefit peregrine falcons, which typically hunt only during daylight. Luckily, for these birds, it never gets dark in Times Square. The pigeons that also frequent these bright spots provide local falcons with an abundant food source, ostensibly at all hours of the day.

Not that these falcons need any help hunting. They are the fastest animal on earth, capable of reaching speeds in excess of two hundred miles per hour. Locally that means falcons are snatching up prey, usually pigeons, at these insane speeds, often right outside the office windows of Midtown. These speedy birds soaring above city streets paint a pretty picture of wildlife conservation, especially considering how close the entire species was to going extinct.

Back in the 1950s, the number of wild peregrine falcons diminished drastically, not just in New York City but throughout North America. DDT was the culprit, as was revealed in Rachel Carson's groundbreaking book, *Silent Spring*. This toxic pesticide weakened falcon eggshells to the point of making incubation unviable. By the 1960s, there were no wild peregrine falcons in North America east of the Rocky Mountains; only a handful remained to the west. It was a crisis.

Tom Cade, a professor of ornithology at Cornell University, is credited with being the first to discover there might be a peregrine problem. In 1970, he formed the Peregrine Fund with about a half-dozen other men. Armed with donated birds from concerned falconers the world over, they embarked on the most ambitious captive-breeding program in history.

Chris Nadareski of the New York City Department of Environmental Protection is New York City's local falcon expert. While discussing

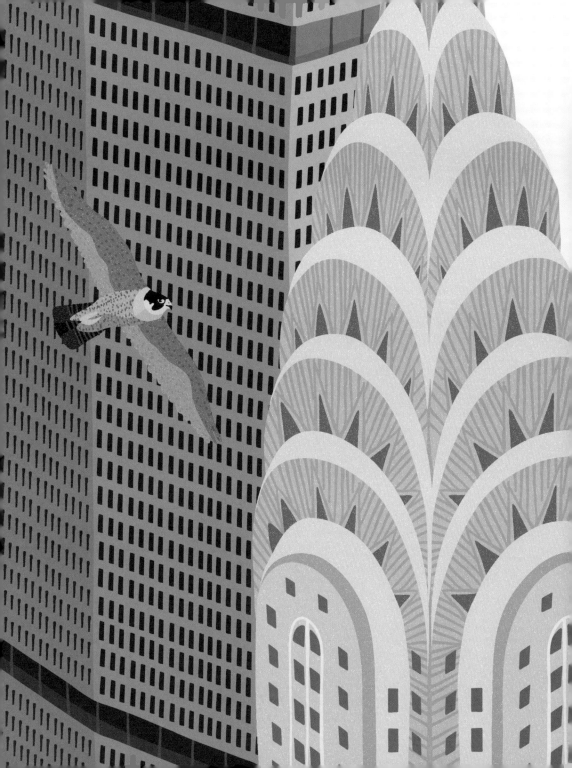

local peregrines, almost in passing, as though it's not a big deal, he goes into a bit of detail on the breeding program's signature method. "Falconers who come very close to their birds were able to mate essentially with the male bird through a specially designed hat," says Nadareski. "A very interesting and complicated thing they did, but also successful."

Why, yes, Chris, that is very interesting—and it's also completely true. Peregrine falcons were literally taught to have sex with specially

documented—with outstanding detail—in Cade and James Weaver's official *Falcon Propagation: A Manual on Captive Breeding* (1983).

To the untrained eye, the hats resemble rubber turbans or maybe pith (safari) helmets. A donut rings the head where the male falcon perches to do the deed. On top is a nontoxic, honeycomb-patterned silicone catacomb structure that acts as the semen receptacle. The hats come in over a dozen colors, including something called safety yellow, and can cost around three

> **This totally ridiculous process, repeated thousands of times over three decades, saved the species.**

designed hats their handlers would wear. Basically, a falconer convinces his falcon over months of daily conditioning that the two of them are mates. Eventually the male falcon mounts the hat (as it sits atop the falconer) and after a brief exertion ejaculates on to the hat. The falconer then uses a capillary tube to collect the semen from the hat, maybe only a drop or two, which is then taken directly to a female falcon and deposited into her oviduct using the same capillary tube from the collection.

The copulation hat was first designed by Lester Boyd, a falconer from Pullman, Washington. It was soon adopted by the Peregrine Fund and

hundred dollars. The website for Northwoods Falconry cheekily warns buyers not to wear it at dinner parties or other public venues.

Admittedly, this is all completely insane—but it worked! This totally ridiculous process, repeated thousands of times over three decades, saved the species. The Peregrine Fund successfully bred and released over four thousand birds back into the wild. The peregrine falcon was removed from the endangered species list in 1999. These raptors have since repopulated almost all of North America, even the cities, including New York City.

According to Nadareski, there are at least fifty birds throughout the five boroughs. Nadareski

doesn't wear one of those fun hats, but he does go to great lengths—and even heights—to assist these local peregrine falcons. Part of his job includes visiting nest sites to band baby falcons. It can be dangerous work, sometimes taking place hundreds of feet above the ground, often involving an angry mother falcon. The tallest of these local peregrine falcon nests sits atop the Brooklyn tower of the Verrazzano-Narrows Bridge, some seven hundred feet above New York Harbor. "You really have to be cautious. They're very quick. They'll come at you without notice," he says. "I often have people come along as bodyguards. They're out there with a broom just holding it up over my head, not swatting it but really just holding it up in place to keep the bird from coming down too low and hitting me in the face or the eye or something." On one occasion, Nadareski had an agitated peregrine fly through the rungs of the ladder he was climbing. But he's also had less stressful banding events, as was the case with a mother peregrine atop the Throgs Neck Bridge, which stood about a foot from Nadareski's leg and calmly watched him as he banded her young.

Biologists like Nadareski go to these extremes because banding provides such valuable information, including how long birds live in the wild and where they fly. The banding also protects resources from local facilities. "When the young birds begin stretching their wings, maybe they fall out of the nest inadvertently," he says. "People often pick them up and drop them off at a wildlife center, like the Wild Bird Fund. Banding avoids overloading the wildlife rehab centers, which basically operate on their own funding sources, and helps get those birds back as quick as possible to the nest site."

One of the more iconic nest sites is on the MetLife Building on East Forty-Fifth Street. Nadareski says the falcons that nest there make a daily flight to the spire of the nearby Chrysler Building in order to gain a better vantage point in hunting for prey. Imagine that: the fastest animal in the world sitting atop the most beautiful building in Midtown. If nothing else, there are few better visual metaphors for urban wildlife than this scene. It's only made more amazing when all the factors that made this possible are considered.

Latin Name	Collective Noun
Phoca vitulina	a harem of seals

Seals

Harbor seal sightings around New York City are once again more commonplace thanks in part to cleaner waters and stricter environmental regulations. The harbor seal sits somewhere in the middle of the local food chain: feasting on herring and menhaden while simultaneously trying to avoid great white sharks. In recent years, seals have been spotted in Orchard Beach, Inwood Park, and Brooklyn Bridge Park. However, the most reliable place for a New Yorker to see a harbor seal is on Swinburne Island, an abandoned island in Lower New York Bay just off the eastern coast of Staten Island. Humans no longer have any use for this small spit of land, but harbor seals have moved in and have been happily, or at least loudly, calling it home.

Swinburne Island is home to nearly one hundred harbor seals, easily making it their most densely populated habitat in the city. It's pretty secluded too, as far as New York City goes: there are no beach walkers to disrupt them, no car horns, and no barking dogs. Swinburne also boasts a number of "haul-out" areas where the seals can easily pull themselves up out of the water. (By contrast, Hoffman Island, which is very close to Swinburne Island and equally secluded, has no good haul-outs and therefore no harbor seals.)

Man-made Swinburne and Hoffman Islands were originally built with landfill in the 1870s to house quarantine hospitals for newly arrived immigrants. Anyone thought to be too sick to pass through Ellis Island but healthy enough not to be sent back home was sent there to convalesce. But with advancements in the field of epidemiology and lower immigration numbers following World War I, quarantine hospitals became less necessary. In the 1930s, the Merchant Marines used Swinburne Island for training, but after that, it mostly went unused. Finally, in 1972, the island became part of the Gateway National Recreation Area, where it is currently managed by the National Park Service.

Initially, the abandoned island was home mainly to cormorants and seagulls. Then the seals arrived. According to Paul Sieswerda, the seals were actually returning to the area. Although seal sightings happened from time to time throughout the years, he believes they came back some time around 2006, and their numbers have increased dramatically since then. The seals owe a lot of their resurgence to the Marine Mammal Protection Act of 1972, which protects seals and other marine mammals. "Previously, they were hunted almost to extinction in these waters," says Sieswerda. "Seals were considered pests that were always getting into lobster traps

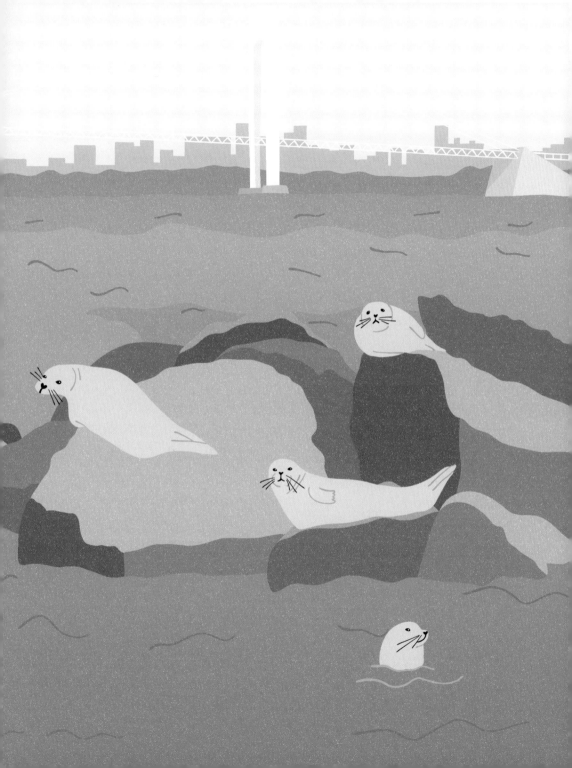

and eating fish, sometimes even destroying the nets. They were seen as varmints."

Sieswerda is a scientist by trade, but like any good New Yorker, he knows a good business venture when he sees one. Since 2010, he has been running seal-watching tours aboard the *American Princess*, the same vessel on which he partners for whale-watching tours.

Swinburne Island can also be reached by kayak, though Sieswerda warns that seals might mistake an approaching kayak, low to the water, for a predator. Either that, or he's trying to sink the competition and get more people to join the tours.

Overall, Sieswerda says New Yorkers should be happy to see harbor seals and other wildlife return because "it represents an indicator of overall ocean and river health." In fact, the waters around New York City have become so healthy that it's invited competition for the harbor seals: the gray seals. Sieswerda observed a similar situation in and around Boston where harbor seals were muscled out by the incoming gray seals in an act of maritime gentrification. The gray seals typically reside in northern New England and Canada. Though they have yet to range as far south as Long Island Sound or New York Harbor in large numbers, Sieswerda swears they are heading this way. "They're bigger and stronger," he says. "I am expecting to see more and more gray seals come in to New York and displace the harbor seals."

It all sounds a bit too much like the New York City real estate market. For now, the harbor seals still have their own island to call home. Holding on to it, however, might be a whole other challenge.

The Newcomers

These animals don't belong here. But then again, New York City doesn't belong here. With its bridges, buildings, and avenues, this city is one of the most altered landscapes in human history. And yet these enterprising, stowaway, refugee critters have found a way to make it here. It's not always been perfect, and it's not always been pretty. But for better or worse, these animals have become real New Yorkers.

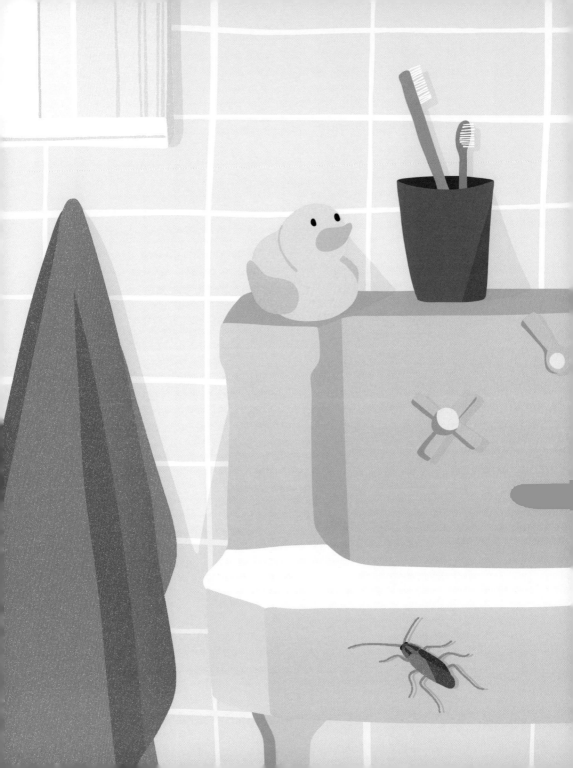

Latin Name	Collective Noun
Blattella germanica	an intrusion of roaches

Roaches

Mark Stoeckle worked as a researcher on the National Cockroach Project back in 2013, but even he can't say for sure how many roaches there are in New York City. "Oh, I don't know," he says, as though he is surprised by such a question. "Take the number of rats and multiply it by a thousand."

Suffice to say it's a very big, probably unknowable number. Plus, there is no single cockroach species. There are thousands of different types of cockroaches, only a few dozen of which are considered pests. In New York City, there are two predominant types of cockroaches, and as any New Yorker will attest, they are most definitely pests. The first is the American cockroach, which is typically a tropical species that nonetheless thrives in the city's warm and damp sewer systems, which Stoeckle likes to call an unintentional terrarium. Aboveground, the German cockroaches are the standard and have adapted, like humans, to living in apartment buildings. "Certainly both of these cockroaches wouldn't be here if we hadn't built a city," says Stoeckle. "The American would not survive the winter. I don't know what the German would do in the wild. But there are certainly more here because we're here. We built a habitat for them."

In fact, roaches are so deeply entrenched in cities that eradicating them probably isn't even possible at this point, nor is it necessarily recommended. New York City may be an urban ecosystem, but it's still an ecosystem. The nature is real. The wildlife has a niche. That is to say, if American and German cockroaches were to somehow—and that's a big somehow—be eliminated, there's a good chance another cockroach species might scurry in to fill the void. That was the fear, anyway, when a Japanese cockroach was discovered on the High Line in 2013.

The classic trope about roaches is that they are so hardy they could survive a nuclear apocalypse. Of course, anyone can make that claim. The real trouble would be finding someone after a nuclear apocalypse to verify it. What's more, reducing roaches to dust by nonnuclear means still makes them a nuisance—and quite possibly a health hazard. According to the American College of Allergy, Asthma, and Immunology, "The saliva, feces and shedding body parts of cockroaches can trigger both asthma and allergies, [which] act like dust mites, aggravating symptoms when kicked up in the air." Put another way, living roaches may be awful and gross, but even when they are dead and their decaying body parts become aerosolized, they still cause trouble. Furthermore, research outlined in the *Environmental Health Perspectives* journal is exploring evidence that early exposure to cockroach

allergens can *cause* asthma to develop in very young children, not just trigger a reaction.

Keeping roaches at bay requires regular fumigation and maintenance upkeep, and all that stuff costs money. In a perfect world, everyone would be able to afford this expense. New York City, of course, is not a perfect world. Cockroach infestations are a real problem, but one that exists overwhelmingly in the city's poorer quarters.

According to an exhaustive atlas of data released by the New York City Department of Health and Mental Hygiene in 2018, the poorest neighborhoods in the city have the most asthma-related emergency room visits for children. Those same neighborhoods also have the most cockroaches.

And, yet, it is not exactly shocking to learn that poor households have cockroaches. Popular culture has primed most people to make this

In New York City, there are two predominant types of cockroaches, and as any New Yorker will attest, they are most definitely pests.

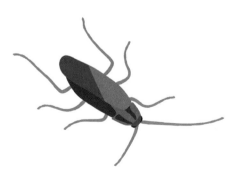

association for decades. Roaches make a fair amount of appearances in music, including in Ghostface Killah's 1996 song, "All That I Got Is You," where he recalls roaches being "everywhere" in his childhood home in the Staten Island housing projects, including the cereal box.

Cockroaches may seem like one of those ubiquitous New York City experiences, however, the data really say otherwise. Even though all New Yorkers may joke and complain about roaches, the reality is that there are not as many reported on the Upper West Side or Brooklyn Heights as there are in the South Bronx, East Harlem, or Brownsville. Tragically, cockroach infestations are primarily felt by poor black and Latino children, specifically in their young lungs. Those filthy little cockroaches are literally choking out low income kids' chances at a healthy childhood.

One organization, AIRnyc, is working with its team of community health workers to help create action plans, reduce hospital visits, and ultimately improve patient outcomes for those affected by asthma. Maybe not surprisingly, this organization is located in the South Bronx where asthma rates—and cockroach sightings—are among the highest in the city.

Latin Name	Collective Noun
Felis catus	a pounce of cats

Cats

The Brooklyn Cat Cafe is more cat than it is cafe. The food is secondary: people come for the cats, usually thirty or so, all available for adoption or at least available to pet.

The cafe opened its present location on Montague Street in Brooklyn Heights in the fall of 2018. It was conceived of by Anne Levin, who has also been running the Brooklyn Bridge Animal Welfare Coalition since 2007.

At adoption events, she noticed many people would come strictly to hang with cats. The problem is these events are notoriously stressful, both for the people and the animals. What Levin really needed was a low-pressure environment where people could spend time with the cats to get to know their personalities better.

And so she created the Brooklyn Cat Cafe, an always-on adoption event. It's a way for potential adopters to see how house cats behave in their natural habitat, which is to say sleeping on furniture, parading around countertops, and lounging on empty shelves. It costs seven dollars per thirty minutes to visit the cafe, all of which goes to the rescue charity. Not surprisingly, it smells like canned fish inside.

However, even this low-key atmosphere can take its toll on the staff. If the team running the cafe seems overwhelmed, it's because of course

they are. These poor folks are quite literally herding cats. Or at least that's what they're trying to do.

Although it can be stressful at times, the endeavor has been relatively successful. Levin adopts out an average of one cat per day, which is about how quickly they take cats in off the streets. Unfortunately, there are so many cats on the streets of New York City in need of a home that this rate of return can sadly continue on for the foreseeable future.

Though nobody can say how many homeless cats there are in New York City, most agree there are a lot. "There's no clear number. There are thousands probably, hundreds of thousands," says Levin. "It could be a million. I have no idea."

Some of these cats were born on the streets. Others were dumped by pet owners who didn't know the proper way to surrender them to a shelter. "People are afraid if they take their cats to the shelter they're just going to die," says Levin. "So instead they set them loose in the street, which is a much, much worse thing to do."

Releasing a domesticated cat into the wild is not good for the cat. Many of the cats are house cats that don't have the experience, or even the right coat, to make it outdoors. A common misconception is that these stray cats will eat rats. However, recent research suggests that most New York City rats are too tough for cats (anyone who has encountered

one of these rats can attest to this). Many of these stray cats die of starvation, exposure, or injury.

All these homeless cats are also bad for the ecosystem. They basically do two things while out in the wild: kill birds and make more homeless cats, which of course only exacerbates the first part of the problem.

The preferred solution for all these homeless cats is to trap, neuter, and then release them back into the wild (TNR for short). A street cat's clipped ear indicates it has already been TNRed. The rest are tended to by an army of mostly unaffiliated volunteers who take to the streets in their spare time, armed with cans of knockoff Meow Mix and a list of veterinarians, all for the sake of the cats.

Still, TNR is not a perfect solution. The problem is with the R, or release portion. These cats may no longer be able to reproduce, but they are still plenty able to kill birds indiscriminately. In fact, directly down the hill from the cat cafe on Montague Street is Brooklyn Bridge Park and its bird sanctuary island. The feral cats who also live in the park show zero respect for the area's protected status, much to the dismay of local birders such as Heather Wolf.

Wolf literally wrote the book on birds in Brooklyn Bridge Park, *Birding at the Bridge*. In her spare time, she leads bird-watching tours. She's personally seen over 165 bird species in the park. Sadly, she's seen a lot of dead birds too. "It's tough," she says. "It's very tough. I lose sleep over it. If you put the cats back [outside], it's still going to affect the birds. We have declining species in this park. But you know people who love cats will do anything to save and protect cats. I love birds and I would do anything to save and protect birds. So I understand their point of view."

It's a complicated issue, but everyone can agree that these cats are not part of the natural order. They are the four-legged manifestations of people's overestimated appetite for house pets. TNR may be a lot of things, but it's not meddling—it's a humane, though imperfect, way to correct a problem that people have created.

Anne Levin of the Brooklyn Cat Cafe sees a whole menu of solutions to feline overpopulation. Neutering is one part of the recipe, but so too is raising public awareness. Directing potential cat owners toward adoption helps too. Ultimately, Levin believes that a lot of people doing a small part can bring down homeless cat numbers across the city. Regardless of how New Yorkers decide to humanely address this problem, it's clear that something needs to be done.

Latin Name	Collective Noun
Rattus norvegicus	a mischief of rats

Rats

For a city that claims to hate rats so much, New York certainly leaves a lot of food out for them. Rats are fed by people regardless of whether the latter realize it: they subsist on waste, litter, and other sins of human thoughtlessness. A mischief of rats is usually the by-product of some human shortcoming. They are scurrying little reminders that people ultimately don't clean up after themselves.

It's hard to count how many rats exist in New York City because they are so adept at hiding, a quality that only reinforces their sneaky reputation. Nonetheless, a recent estimate indicates that there are probably two million rats in New York City, which, of course, is way too many. Mayors from O'Dwyer to de Blasio have vowed to get rid of them, though to date none have succeeded. Mayors come and mayors go, but the rats remain. In 2015, the de Blasio administration unveiled their rat plan, which promised to strike at the heart of "rat reservoirs" and not just scratch the surface of the problem. Matt Flegenheimer, reporting for the *New York Times* on the de Blasio rat plan of 2015, seemed to eye-roll at the hubris of it all. "There have been 109 mayors of New York," he wrote, "and, it seems, nearly as many plans to snuff out the scourge. Their collective record is approximately 0–108." At the time of this writing, New York's rats remain undefeated.

It would be a huge and probably impossible undertaking to rid the city of rats. Poisoning rats would introduce the toxins into the food chain, specifically via the red-tailed hawks, which eat the rodents. And according to a study released in 2017, a single pair of mating rats can produce nearly a half-million rats in only three years. The city could attack the primary food source by sealing its trash bins, which to be fair, was part of de Blasio's plan. But, ultimately the street space needed for trash storage would butt up against the space needed for car storage, or as drivers call it, "street parking." Until New York adopts a more thoughtful food-waste strategy, there are going to be rats, and lots of them, all happily thriving.

In 2015, discarded human food was at the center of a local celebrity rodent known as "pizza rat," who went viral in the nonclinical sense of the word. In the widespread video, this rat appeared to drag a remarkably intact slice of pizza down a flight of subway stairs. Months later, "selfie rat," the critter who unbelievably took a picture of itself on the smartphone of a sleeping subway passenger, gained a certain notoriety. Though these instances spoke to New Yorkers' shared experience, they were both more than likely staged with trained rats, fake news. Still, that a rat could be trained to do any of these things is exceptional in its own right.

Rats are quite intelligent, probably more intelligent than many realize. (Just ask the scientific community, who have been using rats for testing because of their biological and behavioral similarities to humans.) Although the rats probably don't appreciate this vote of confidence in their cognitive abilities, humans should certainly be grateful for their sacrifice, as there's no telling how many medical advancements have derived from testing on them.

In a more natural setting, rats demonstrate a usefulness in aerating soil. But this is New York City, where there is little need for natural soil management and therefore city rats have no clear ecological benefit here. It would be cool if they ate bedbugs or something like that, but no. They are just rats who are out for themselves, serving human New Yorkers no purpose whatsoever. But perhaps this whole paradigm is wrong and it's really not up to other animals to benefit people.

> **They are just rats who are out for themselves, serving human New Yorkers no purpose whatsoever.**

Rats' social structures are extraordinary in their complexity. Female rats can give birth to their offspring at a synchronized time, which allows the community to raise their young together. And even though it seems there are rats everywhere in New York City, they actually hew to somewhat restrictive genetically informed neighborhoods. For example, a Greenwich Village rat could not up and move to Inwood. The uptown rats wouldn't accept the downtown ones. Similarly, a rat arriving on a ship from overseas wouldn't make it very long anywhere in New York City because no local rat community would accept it into the ranks.

Sometimes they just exist in their own right, and maybe that's none of humanity's business.

What's more, it certainly takes a lot of gall for people to call another species invasive, diseased, and too numerous. Based on what humans have done to the planet, we have a lot of nerve saying another animal is eating up all the resources, having too many offspring, and leaving the place a goddamn mess.

Maybe that's just it. Perhaps in some unconscious way, humans see themselves in rats, and maybe, quite possibly, that's exactly why the rodents are so hated.

Latin Name	Collective Noun
Sturnus vulgaris	a murmuration of starlings

Starlings

One March morning in 1890, Eugene Schieffelin walked from his Manhattan home on Madison Avenue and Seventy-First Street to nearby Central Park, carrying with him a few dozen European starlings in cages. Without much fanfare, Schieffelin released the birds into the Manhattan morning. Schieffelin, a pharmaceutical manufacturer, was originally from Germany. The starlings were also originally European, imported from England.

There were two reasons why Schieffelin released the birds that morning. For one, he was a member of the American Acclimatization Society, an organization dedicated to introducing European flora and fauna to North America. They did this sort of thing all the time. The feeling was that America's nature was not as refined as Europe's and therefore needed a little human intervention. Second, Schieffelin was a big fan of William Shakespeare.

These two seemingly unrelated facts intersected that March morning as part of Schieffelin's grand plan to release every bird ever mentioned in Shakespeare's plays into New York's Central Park. Previously, he had released bullfinches, skylarks, nightingales, and dozens of other birds. Almost none survived in this unfamiliar habitat.

The starlings he released, however, did survive and went on to achieve stunning success for their species in their new home and beyond. Today, there are approximately two hundred million European Starlings across North America. And it is believed that every single one, from Alaska to Mexico, can trace its lineage to Eugene Schieffelin's tragicomic gesture.

The birds were introduced because of Shakespeare, but the subsequent years have been more akin to *Jurassic Park*, a worst-case scenario of wildlife running amok with unintended consequences. And let's not forget, birds are basically just tiny little dinosaurs.

"The introduction of a species is not an easy thing to do," says Dr. Susan Elbin, director of conservation and science with the New York City Audubon Society. "But some of these birds are just very good at surviving and being generalists and adapting to different situations." Of the city's starlings specifically, she says, "They've just done great for themselves. The irony is that in England, they have declined."

As for Schieffelin's motivation, the starling is in fact mentioned, albeit very briefly, in the opening act of Shakespeare's *Henry IV, Part I*. This minor mention ultimately led to a leading role for the European starling in North America's ecology—though some might say it plays the villain.

Physically speaking, starlings are small birds, typically about 8 inches long. They have black plumage and are usually marked with iridescent green and purple specks. They flock in huge numbers, which are called murmurations. Individually, they are very dense, sometimes referred to as feathered bullets. This combination of factors makes them particularly dangerous to aircraft, as evidenced by the October 4, 1960, Eastern Airlines Flight 375 from Logan

of starlings every year, as in over a million. In 2014 alone, the US government culled 1,140,331 starlings. Incredibly, it made almost no impact on the health of the species.

Starlings are also responsible for loss of habitat for other birds. They're kind of bullies, in fact, forcing bluebirds, woodpeckers, and other species to flee their nests. They can also do harm to humans. A dangerous fungus, *Histoplasma capsulatum*, can grow in their feces.

"

They're kind of bullies, in fact, forcing bluebirds, woodpeckers, and other species to flee their nests.

"

airport in Boston, which struck a murmuration of starlings shortly after takeoff and crashed into the sea. It was the worst aircraft bird strike incident in history and resulted in sixty-two human deaths.

Schieffelin's starling release was so successful that the International Union for Conservation of Nature lists the bird's status as "least concern." On the flip side, many see the birds as pests, an invasive species. The USDA believes the birds divert grain supplies from cattle, which leads to a decline in dairy production. Hoping to rectify this, the federal government kills—or culls—a lot

By almost every measure, Schieffelin's gambit was a foolish display of hubris. Nearby, on Broadway, they might even call it a flop. There was no way he could have known how poorly his actions that morning would later play out across Manhattan and even the entire continent. Or was there? In the third act of *Henry IV, Part I*, a warning of what can happen when we recklessly tinker with the environment is issued: "Diseased nature oftentimes breaks forth in strange eruptions."

If only Schieffelin had paid more attention to Shakespeare's words than he did to Shakespeare's birds.

Latin Name	Collective Noun
Cimex lectularius	an "insomnia" (some might say) of bedbugs

Bedbugs

I n the early 2000s, New Yorkers began living in fear of bedbugs. Unlike other urban vermin, which typically coincide with poverty or even unsanitary life choices, these pests were afflicting even the most well-heeled and well-behaved New Yorkers. There were bedbugs in offices, riding the trains, and on just about every New Yorker's mind.

They became something of a local obsession. CBS News dubbed 2010 "The Year of the Bed Bug." The nasty little critters were having their moment. Still, they were by no means a "new" thing. According to folklore, bedbugs first arrived in North America aboard the *Mayflower* along with the pilgrims. Bedbugs, which can also prey on birds or bats, often wherever those animals sleep, remained fairly common in the United States right up until the end of World War II, when their numbers diminished drastically with an uptick in pesticide use.

Eventually, it seems the bedbugs adapted a resistance to DDT and were able to rapidly recover. Their turnaround was so remarkable that in the 2000s, it appeared as though bedbugs were infesting the city, and very suddenly at that.

According to New York City's Department of Housing Preservation and Development, there were fewer than one hundred confirmed bedbug violations in 2004. Six short years later, in 2010,

that number skyrocketed to nearly five thousand cases. Though the jump in bedbug activity seemed odd, according to journalist and author Brooke Borel, it was "weirder that they ever went away."

In the 2015 *Infested*, Borel writes, "I began to understand what I think is the most intriguing aspect of the bedbug's story: that they are back today isn't a fluke. It is a return to normal, an ecological homeostasis."

Borel is a science journalist by trade, with bylines in *Popular Science*, the *Atlantic*, and *Audubon*, among many other publications. Unfortunately, Borel also has personal expertise with bedbugs, having contracted them four or "maybe even five" times. For better or worse, she's an expert. She even coined their collective noun, "an insomnia of bedbugs," based partly on how the experience of having them kept her up at night.

Borel is not a hoarder. She doesn't go dumpster diving, shop exclusively at thrift shops, or exhibit any other "risky" behaviors. She's probably just one of those biologically unlucky people who are more susceptible than others to showing a reaction to bedbug bites. According to the Centers for Disease Control and Prevention's website, "Because bed bug bites affect everyone differently, some people may have no reaction. . . . Other people may be allergic to the bed bugs and can react adversely to the bites."

Well, Borel certainly had a reaction, as did thousands of other unfortunate New Yorkers. She says there may be a few additional factors at play in the bedbug resurgence. First, international travel became easier. People are visiting more places and "bedbugs are very good hitchhikers." Second, there are more people living in cities than ever before, which makes it easier for the insects to jump from one host to another. A person living in the suburbs doesn't have to worry too much about her neighbor's bedbugs moving across the street into her house too. The same cannot be said for someone living in an apartment building. Third, and maybe most important, the scientific community had all but stopped studying the vicious little monsters. "There was no reason to study bedbugs," says Borel. "They weren't around."

Unlike some feel-good stories about resurgent wildlife, the return of bedbugs hasn't been a boon for the ecosystem. They serve no obvious purpose, which is fine in that animals don't need to *do* anything for people. But as far as people are concerned, they are nothing more than an itchy inconvenience—ruthless, bloodsucking, opportunistic stowaways. Even their method of reproduction is objectively horrifying, culminating in something called "traumatic insemination," which is pretty much just what it sounds like.

There are some who think the bedbug craze may even have had a negative impact on human reproduction, or at least on dating. A 2011 Huffington Post article asked if bedbugs were killing romance, due to the stigma associated with having them. Borel likened having bedbugs to being blacklisted or even having an STD. Borel suggests many things to avoid bedbugs, including not picking up used mattresses or other furniture from the street, carefully inspecting hotel linens, washing clothes in hot water, and generally avoiding clutter.

Bedbug infestations are completely democratic. Unlike mice and cockroaches, which are usually attracted to food or trash and can often be kept at bay with some proactive cleaning, bedbugs require little more than an unwitting host. They usually convene in the bedroom but have also been known to strike at movie theaters and even the subway. Pick the wrong seat, and that's all she wrote. While there are certainly some things people can do to avoid bedbug infestation, in the end, they are attracted to body heat and the carbon dioxide emitted from an exhale. Therefore, to be human is to be at risk of attracting bedbugs.

When a bedbug bites, it can last a terrifying eight minutes, a process during which the insect's body can double or even triple in size as it inflates with a slumbering person's own blood. At times, it feels less like these critters are merely inconvenient wildlife and more like inveterate hunters preying on sleeping New Yorkers. "They have adopted the simplest eating strategy an animal can have, which is to sit and wait for food to arrive," writes Borel. "The bugs have no reason to fly because we always return to our beds, just as birds to their nests and bats to their roost."

This is partly why bedbugs are simultaneously so scary and so captivating: they represent a novel form of terror, one that cannot be completely avoided. New Yorkers are used to being scared. It's understandable to be afraid of walking down a dark city street in some strange neighborhood. But to be under attack by an unseen assailant while sleeping in bed? Well, that just seems like a new kind of nightmare.

Latin Name	Collective Noun
Canis latrans	a pack of coyotes

Coyotes

New Yorkers began spotting coyotes in the 1990s. They were seen scavenging around Woodlawn Cemetery in the Bronx, the only city borough physically connected to the rest of the country. Those pioneering coyotes probably wandered across the city limits for a visit. However, in the intervening decades, their local numbers have grown steadily—and not just in the Bronx—as the species has successfully shifted from occasional tourist to permanent resident.

Coyotes are not from these parts. Rather, they arrived here as part of a generations-long eastward migration. They came to New York City for the same reason a coyote goes anywhere: in search of food, mates, and a place to live. While it's certainly new territory for them, adapting to a strange environment with an unfamiliar set of circumstances is exactly what coyotes do best.

Gotham Coyote has been tracking these animals since 2010 and estimates that New York City is home to about twenty coyotes, plus another dozen that "wander in" from time to time. Coyotes are notoriously shy creatures, so Chris Nagy and the team at Gotham Coyote have taken to tracking them at a distance with unobtrusive motion-detecting cameras. "We first found dens in the northern Bronx," he says. "Then we discovered more every year. Any place we put a camera, we would get a coyote. They are in the obvious big wooded places, like Van Cortlandt Park, but also in the smaller parks."

In 2015, Gotham Coyote discovered a den in Queens, a sign the wild canid was expanding its metropolitan range. According to Nagy, "All the good spots had already been occupied in the Bronx."

The Queens coyote craze officially hit the ceiling in March of that same year when a coyote was found on the roof of LIC Bar in Long Island City. It's still unclear how it got up there, though perhaps the bigger mystery is how it got across the water to Queens in the first place. Nagy believes train tracks and bridges provided a corridor, as the first Queens coyote was found within walking distance from the Triboro Bridge. Train tracks may also explain the handful of coyote sightings in Manhattan, including the one that wandered as far south as TriBeCa in 2010. That coyote most likely ran across the causeway at the northern tip of Manhattan, though Gotham Coyote has yet to find a permanent resident in Inwood Park or anywhere else in Manhattan. The coyotes thus far spotted on the island, including the one photographed in Central Park in 2019, have been tourists. Regardless of where they end up in the city, though, Nagy believes these animals can provide a great biological benefit.

"Any time you have a more diverse and robust food web, you have a more efficient and effective ecosystem. The coyote aids in nutrient cycling, water filtration, biodiversity, even aesthetic and intrinsic value. People value wildlife," says Nagy. "If we can learn to live with this slightly large carnivore, then it bodes well for maintaining this entire system."

Nagy suggests recent parkland development along the West Side of Manhattan could be actively aiding coyotes too. He explains, "If

in name than in practice. A small portion is manicured, but the bulk of the sixteen-acre park is overgrown and fenced off. It's full of squirrels, birds, and other small bite-size animals. People don't seem to spend much time there, which makes it all the more perfect for the shy coyote who lives there.

Many of the park's neighbors had not heard about their wild neighbor, although one older man, who lives a half block from the park, proved the exception, saying, "I'm not surprised. It's like

> **"**
> # Coyotes aren't vicious creatures out to kill beloved pets, but they are opportunistic.
> **"**

you look at the map, there's a green strip from Peekskill down to the Hudson River Park. There's almost all green down the west coast of the Bronx and Manhattan."

Truly, there's a lot more open space in New York City than people may realize. A lot of it is true parkland, but a good proportion of this open space comprises "edges," or small odd-shaped parcels of land that often go underutilized by human New Yorkers. Coyotes, however, have figured out exactly how to get the most out of these spaces.

One example is Railroad Park in the Rochdale neighborhood of Queens, which is more of a park

a forest in there." The residents who do know about the local coyote are understandably a bit nervous about it, especially those with pets. "We went out to teach people how to coexist with this animal," says Richard Simon, director of the Parks Department Wildlife Unit. "Over time, the fact that it has not attacked other animals, has not attacked people, just kept to itself . . . it's a testament to the fact that a coyote can live in a relatively small plot of land and not cause trouble."

The uptick in coyotes is one of the reasons the Wildlife Unit was created in 2016. According to Simon, the animals are almost always harmless. The trouble usually comes when people try to

feed the coyotes, either directly with food or indirectly by, say, leaving a small animal outdoors overnight. Coyotes aren't vicious creatures out to kill beloved pets, but they are opportunistic. Simon believes it's this same tendency that brought coyotes this far from their original range. "The movement east has been gradual, but it's mostly due to human manipulation," he says "We cut down forests and put in fields and farms. And that mimicked the open plains coyotes would have out west. We also killed off the predators that existed in this part of the country, including mountain lions and wolves. Coyotes are filling that void."

Ideally, these coyote newcomers would eat rats, geese, and maybe even some of the excess garbage. Technically, they are generalists, so

it could happen. But their diet also includes nuts, berries, even shellfish if it's available. This dietary flexibility is part of what makes them so successful.

One thing coyotes do not have much of an appetite for, however, is conflict, and this is another key to their success. As Simon says, "Most coyotes will do their best to avoid people. More often than not, a successful coyote is probably not very far away from us and we just never see it."

These coyotes may be new to town, but they have already shown a knack for city living. They are happy to live in cramped spaces, eat all kinds of food, and are very reluctant to bother their neighbors. In other words, they are perfect New Yorkers.

Latin Name	Collective Noun
Aedes aegypti	a scourge of mosquitoes

Mosquitoes

It can't be overstated how quickly New York City's human population grew in the nineteenth century. In 1800, there were 60,000 people living in Manhattan. By 1900, that number swelled to 1.8 million. That's nearly a 3,000 percent population increase in just ten decades. The world had never seen such rapid urbanization. There were literally thousands of people pouring in every day, and humans and nature collided like never before.

Disease was one check on this otherwise unrestrained growth. New York City was an unhealthy place generally, but in those days, poor immigrant communities were hit the hardest. There were few regulations then: sanitation was nonexistent, and epidemics would run rampant, kill hundreds, then disappear, before popping up again years later without any warning. Yellow fever was among the deadliest diseases of the nineteenth century. Though few knew it at the time, it was transmitted from one unlucky New Yorker to another by the bloodthirsty mosquito.

Mosquitos are to blame for quite a lot. According to Timothy Winegard's *The Mosquito*, mosquitos, specifically the female ones, are responsible for killing half the people who have ever lived. They quite possibly killed Alexander the Great and may have swayed the American Revolution. They are not some campfire nuisance—they are humanity's apex predator.

And they are terrifying. When they attack, they first anesthetize the skin before sawing it open and taking enough blood to triple their body size. It's not personal: they're doing it for their babies. This process by itself is not necessarily deadly, but mosquitos are often vectors for several viruses, including Zika, malaria, and yellow fever, which they leave behind as a parting gift.

Winegard writes that "the deadly yellow fever virus disembarked in the Americas with African slaves." The first cases of yellow fever were reported in New York City in 1702. The first local epidemic, however, broke out in 1795. Three short years later, in 1798, yellow fever killed over seven hundred city residents. That may not sound like a lot, but in a city with only sixty thousand people, this death toll amounted to more than 1 percent of the city's total population. The equivalent today would be eighty thousand people, or around the population of Park Slope, Brooklyn, getting wiped out.

A year later, in 1799, the city responded by allocating a relatively isolated stretch of Staten Island's coastline to house the New York City Marine Hospital. It was located just south of the present-day ferry terminal. Any sick passengers

arriving by ship to New York City were sent to Staten Island to recuperate.

The city used eminent domain to build the controversial campus. It was just one of many reasons the locals hated Quarantine Hospital, as it came to be known. A hundred years later, Staten Island, by way of Fresh Kills landfill, would be asked to house all the city's garbage too. (If New Yorkers from the outermost borough appear to have a chip on their shoulder, these actions may explain why.)

to escape the health hazards prevalent during summers in the city. In no small way, these places indirectly gained popularity thanks to the pesky mosquito. Consequently, the area of southern Brooklyn once known as Yellow Hook hoped to avoid any connection with the epidemic and changed its name to Bay Ridge.

The quarantine hospital, though unpopular, remained relatively undisturbed for fifty years. That was until 1848, when a yellow fever epidemic broke out in Staten Island, leaving thirty locals

"

In no small way, these places indirectly gained popularity thanks to the pesky mosquito.

"

At the time the quarantine hospital was built, little was known about infectious diseases. Furthermore, few New Yorkers, if any, understood the role mosquitoes played in spreading them. Many people blamed these epidemics on the wretched living conditions of the poor and immigrant classes. The prevailing sentiment was that these people somehow brought the diseases upon themselves, an argument that would be echoed more than a century later during the AIDS epidemic.

During this era of epidemics, wealthy city residents would flee to places like the Hamptons, the Jersey Shore, and the Hudson Valley in order

dead. A few years later, in 1856, another eleven Staten Islanders would succumb to the same disease. The panic among locals became infectious. One Staten Island newspaper of the day ominously wrote: "The dead of 1848 speak to us from their graves. Shall we forget them?" Staten Islanders responded to this rhetorical question with a resounding *hell no* and proceeded to pursue their brutal, albeit misguided, vengeance upon the quarantine hospital.

In 1857, the city tried to solve the problem by committing to relocate the hospital to a more secluded section of Staten Island. But arsonists burned that in-progress construction site to

ashes before it was even halfway built, which should provide some insight into how Staten Islanders felt about the compromise.

A year later, on the evening of September 2, 1858, "a large party disguised and armed," stormed the quarantine hospital grounds, according to the *New York Times*. The patients, mostly bedridden and understandably confused immigrants, many of whom didn't speak English, were lifted in their mattresses and taken about a hundred yards from the buildings, which were then set on fire.

It was quite a sight, this Quarantine Conflagration, as it came to be known. The flames could be seen all the way in Manhattan. In a subsequent *Times* story, the ire for the hospital was palpable: "burning Quarantine has for a long time been deemed a pardonable offence by some Staten Island men."

Not surprisingly, the story had a tragic outcome. Although none of the sick immigrant patients died that night, even if they were blamed for that which the mosquitoes did, one dockworker was fatally shot while attempting to stop the angry mob.

A silver lining to all this was the creation of the Metropolitan Board of Health in 1866, which would go on to become the New York Department of Health and Mental Hygiene. Public health reform didn't happen overnight, but eventually this city service would become a gold standard for public health administration. It's this department's innovative and tireless work that allows New York City's urban experiment to persist.

Jane Jacobs, the mother of modern urban planning, writes in *The Death and Life of Great American Cities*, "Cities were once the most helpless and devastated victims of disease, but they became great conquerors. All the apparatus of surgery, hygiene, microbiology, chemistry, telecommunications, public health measure, teaching and research hospitals, ambulances and the like . . . are fundamentally products of big cities and would be inconceivable without big cities."

In other words, it is a city's ability to draw on a diverse collection of experiences and expertise that allows it to effectively combat challenges like those presented by the mosquito. Immigrants, on the other hand, were never really the problem. More than likely, they were part of the solution.

Latin Name	Collective Noun
Myiopsitta monachus	a pandemonium of parrots

Parrots

The most unlikely attraction at Brooklyn's Green-Wood Cemetery is a group of loud, colorful, possibly illegal immigrants: the monk parrots. These birds are native to several South American countries and have bright green coloring complemented by gray hoods, hence the monastic designation. Like most human New Yorkers, they are not originally from here—the ones at Green-Wood Cemetery, specifically, come from Argentina. Or so says Steve Baldwin.

Baldwin leads parrot safaris at Green-Wood Cemetery one Saturday a month. He's not an ornithologist but rather more of an enthusiast, a self-made expert. He says the story of how these chatty birds, also known as monk parakeets, found their way to Brooklyn goes back about fifty years.

In Argentina, monk parrots were seen as pests that overate crops, thereby preventing economic gains. To solve this, Argentina invested in bounty hunters. Yet despite killing nearly a half-million monk parrots, their population basically remained unchanged.

So, according to Baldwin, Argentina went to plan B, which was to sell the parrots to America, where a market for exotic birds was beginning to soar. According to the *New York Times*, nearly twelve thousand monk parrots were brought to the United States in 1968 alone.

Exactly how these birds got to Green-Wood Cemetery is a bit fuzzy, but there are a few theories. A popular version of the story says they escaped from an unmarked crate at JFK airport (or as Baldwin puts it, "They came in the same way most immigrants come in, right through the airport").

However it happened, the monk parrots had become a local fixture. Trouble came for the released birds in April 1973 in what the *New York Times* called a "war against the flamboyant invaders from South America." Though colorful and unique, introducing a new species to an existing ecosystem is generally not a good idea, because it can throw the whole thing off balance. Accordingly, Baldwin says half the parrots were killed immediately by wildlife officials, while the remaining birds took refuge on Rikers Island. Then the exterminators were delayed due to paperwork, which gave the surviving pandemonium of parrots time to flee for their literal lives. They flew south to Brooklyn, to Green-Wood Cemetery, where they have been ever since.

This unlikely habitat has provided Baldwin with a new calling in life: leading flocks of eager bird-watchers who hope to spot the infamous parrots. He believes this kind of wildlife is even more important for those living in cities. "We need a break! We sense the loss from the whole

mechanized world we're in, man," he says, then stops here to laugh at himself. "It's certainly not the most important issue in the world . . . but it's a nice feeling to know these animals are out there."

Though this is a relatively new gig for Baldwin, birds have always been a part of his life. Growing up, his family had their own parrot, an African gray they bought from a pet store on Bleecker Street. Years later, Baldwin was walking through Central Park with his teenage daughter, when they came upon a crowd protesting the eviction

including CNN, the *New York Times*, Reuters, and many others. It's certainly an enjoyable way to spend a Saturday morning in Brooklyn.

Officially speaking, Green-Wood Cemetery has no official position on Steve Baldwin or his safaris. According to Chelsea Dowell, former manager of programs and membership, Green-Wood is thrilled whenever people come to view the birds. "Green-Wood has always been a place where people enjoy nature," she says. "These birds are just one more facet of that."

> **"**
>
> ## Their nest complexes are akin to apartment buildings, with up to a dozen parrot couples breeding and roosting within their individual chambers.
>
> **"**

of two red-tailed hawks. It was Pale Male and Lola, the famous birds who had made their nest on the facade of a fancy Fifth Avenue apartment building. Baldwin soon "fell in" with this bird crowd and could be found in his free time chanting "Bring back the nests!"—often while wearing a full-body, bright red cardinal costume. After the hawks were spared eviction, Baldwin was alerted to another group of birds, this time the squatting, squawking parrots out in Brooklyn.

Since Baldwin began working with the parrots, he's become somewhat of a celebrity. News crews have joined him on his parrot safaris,

The main attraction on these safaris is the grand archway lording over the cemetery entrance near Twenty-Fifth Street and Fifth Avenue, where about a hundred monk parrots have made their home. Originally designed by Richard Upjohn, who also designed Trinity Church on Wall Street, the brownstone structure boasts countless eaves, nooks, and crannies, which in addition to thrilling architectural enthusiasts, are also ideal for parrot nests.

Monk parrots are communal breeders. Their nest complexes are akin to apartment buildings, with up to a dozen parrot couples breeding and

roosting within their individual chambers. In this small way, they further mimic the immigrant experience of New York City: living in close quarters with their own kind, often in high-rises, thousands of miles from home.

Plus, they speak a language all their own. Aside from the mimicry generally associated with these birds, ornithologists posit that parrots have around fifteen unique vocal commands, conveying anything from mundane information to the more urgent warnings of incoming danger.

Hawks and crows are their primary predators, though some might say that Con Edison, New York City's utility provider, also poses a threat: another parrot pandemonium in Brooklyn has been known to nest atop Con Ed electrical transformers. The parrots are drawn to the height and stability of these structures, not to mention the warmth. However, this living arrangement has led to short-circuiting, some localized blackouts, and even fires. As a result, Con Edison has frequently had to disrupt the nests.

At Green-Wood Cemetery, however, the birds thrive, with only the occasional hawk or crow to discourage their efforts. The parrots appear to have been granted a reprieve, and at a graveyard of all places. They have also provided nourishment for nature-starved New Yorkers.

"They are a wild element we don't normally have in the city," says Baldwin. "But life is right here too, man. There's still magic here in New York City."

Latin Name	Collective Noun
Columba livia	a kit of pigeons

Pigeons

New York City is home to an estimated one million pigeons. That's unofficial, of course—nobody has ever actually counted them. Still it certainly *feels* right to anyone who has spent even five minutes in New York City. There are pigeons all over the damn place. Many refer to them as "rats with wings," an unfortunate and inaccurate nickname.

Luckily for pigeons, they have found an ally in the Wild Bird Fund, New York City's only wildlife rehab center. On the Upper West Side, staff members tend to thousands of injured pigeons a year while simultaneously repairing the bird's needlessly wounded reputation.

From the outside, the Wild Bird Fund looks almost like any other storefront. The inside, however, is flocking with patients. Although they care for all types of birds here, the majority of the patients are pigeons. In fact, their intake figures from 2017 indicate an average of more than eight pigeons a day. When presented with this statistic, Rita McMahon, the director of the Wild Bird Fund, takes a pause before laughing. "Oh, God," she says. "That's probably about right."

New York City has a reputation for being a cruel and uncaring place. Yet eight times a day some New Yorker cares enough to bring an injured "rat with wings" into the Wild Bird Fund.

On social media, another notoriously unkind space, the Wild Bird Fund tweets out the location of injured birds to their thousands of followers who answer the call and bring these injured birds in to receive care. "It's amazing. The people who bring them in are from all walks of life and travel great distances to bring the birds here," says McMahon. "They see that injured bird and they connect with it."

McMahon has always loved animals. As a young child, she unsuccessfully attempted to nurse poisoned pigeons back to health. Years later, as an adult, McMahon saw an injured goose on the side of the interstate. Overcome with compassion, she hit the brakes, grabbed the goose, and brought it home to convalesce at her apartment. McMahon soon discovered New York City didn't have a wildlife rehabilitation center, so in 2005 she cofounded the Wild Bird Fund.

Admittedly, a hospital for pigeons may sound odd. However, disdain for these birds is much more peculiar. That's because pigeons have been in service to humanity for over five thousand years, during which they provided food, fertilizer, and a long-distance communication solution that predates AT&T by several millennia.

Probably the most incredible thing about a pigeon, though, is its homing ability. This mysterious talent allows a pigeon released hundreds

of miles away—even in a place it has never been before—to fly directly home without stopping. Nobody is quite clear how this works. But it does work, and it has for thousands of years.

News of Napoleon's defeat at Waterloo was delivered by pigeons. International news organization Reuters initially began as a flock of pigeons carrying stock news across Belgium. There is also that great army pigeon, Cher Ami, that saved the lives of nearly two hundred soldiers during World War I and presently sits stuffed on

keep the birds captive. Either way, the marriage dissolved. And for better or worse, the current feral pigeon situation—the one that has pigeons all over the place—was created by humans. Pigeons didn't migrate on their own to conquer the world. With very few exceptions, these birds are where they are in the world because humans brought them there.

McMahon sees this as an opportunity, as she believes pigeons can still contribute to humanity. And she's not alone. In the 1970s, the Coast Guard attempted to train pigeons to search for

> **66**
>
> # Instead of grass and seeds, city pigeons adapted their diet to include bagels and pizza crust. They're making it work.
>
> **99**

permanent display at the Smithsonian Museum of American History in Washington, DC.

But somehow, over the years, pigeons fell out of favor. With the rise of industrial fertilizer, telegraph wires, and advanced chicken farming, their usefulness to humans became obsolete, and from there, it was only a short flight to becoming seen as nuisances or pests.

Today, pigeons don't enjoy any of the protections afforded to wildlife. That's because technically they're not wild. Pigeons are feral, which is a return to a natural state after a stint in domesticity. At some point in time, pigeons escaped human clutches, or people stopped caring enough to

shipwreck victims at sea. (Despite reports indicating that these rescue pigeons "remain vigilant to complex visual tasks for many hours" with a staggering 90 percent success rate, the program was eventually abandoned.) Famous American psychologist B. F. Skinner, worked extensively with pigeons too. Incredibly, he even taught some to play Ping-Pong. "Their ability to notice pattern is superior. They come out higher in intelligence tests than any other birds," says McMahon. "They can recognize the entire alphabet. They can even read mammograms."

Pigeons also contribute to the local ecosystem, though probably not in a way they enjoy.

Specifically, the once-endangered peregrine falcons have returned to New York City in record numbers thanks in part to the seemingly inexhaustible supply of pigeon food.

Oddly, while pigeons remain unloved, their close relative, the dove, is widely adored. Biologically, the two birds are nearly indistinguishable. As a friend of mine once observed, "A dove is just a pigeon that went to private school."

Regardless of how people feel about them, these birds continue to thrive. McMahon believes it's because of their flexibility. "They look at a situation and try to figure it out," she says. "They adjust their behavior to take best advantage of the situation." Indeed, the building ledges in cities where feral pigeons nest are an adaptation on the cliff outcroppings where they would roost in the wild. Instead of grass and seeds, city pigeons adapted their diet to include bagels and pizza crust. They're making it work.

According to McMahon, it's now up to humans to adjust their perceptions of pigeons. "If we can get people connected to the pigeon, hopefully they will connect with nature and then they will care and make changes. That's the paradox of the bird that many treat with disdain: it may be the bird that can save us."

To be clear, what McMahon is saying here is that appreciating pigeons can save the environment . . . and she's not the only one saying that. The paradox she refers to comes from an academic journal article from the December 2006 issue of *Conservation Biology*, titled "The Pigeon Paradox: Dependence of Global Conservation on Urban Nature." According to the authors, there are three parts to the paradox: First, current conservation efforts are insufficient. Too many species are at risk. Second, people are more likely to take conservation action if they had direct experiences with nature as a child. However, third, with more people living in urban centers, nonnative species, like the oft-reviled pigeons, are the best chance urbanites have to connect with nature: "If our assertions are correct," report the authors, "the future of thousands of species and many ecosystems depends on urbanites' interaction with urban nature."

McMahon echoes the importance of children and urban wildlife: "A city kid can connect with a local flock. They can relate to something that's other than themselves and also managing it in New York."

Sure enough, it was a childhood encounter with pigeons that ultimately led McMahon to start the Wild Bird Fund. That hypothetical city kid she mentions too would be more likely to advocate for wildlife preservation as an adult, which, given the specter of fast-approaching climate change, could be a boon for humanity's own preservation. Locally, New Yorkers would be smart to change their pigeon perspective. They ought to start loving these maligned birds a bit more, at least for the children's sake. After all, the fate of the entire world just might depend on it.

Where the Wild Things Will Be

New York City has arrived at a remarkably wild moment in its history, but it didn't get there by accident. Significant ecological amends, including expanded parklands and stricter environmental regulations, made this happen. These animals are the proof it's working.

Of course, there's always more that can be done, and the city would be wise to continue investing in open spaces, green initiatives, and environmental remediation. As with all progress, critics will say it's too expensive, that it will hurt business and that allocating too much land for public use will make traffic worse. They will call it a pipe dream.

But think about it: Has this kind of investment ever been a mistake? Has anyone ever stood in a pedestrian plaza and yearned for more cars? Has anyone seen an acre of grass and wished for pavement instead? Has any city, anywhere, ever built a park, then regretted it?

One of the city's newest parks is Brooklyn Bridge Park, consisting of roughly one hundred acres of converted industrial shoreline. From there, you can see four boroughs, two states, the skyline, and Lady Liberty. You can also see turtles, opossums, raccoons, muskrats, lion jellyfish, and, if you're really lucky, humpback whales and harbor seals. You can also find more than 160 species of birds in the park, including rare ones like the sora, the lark sparrow, and the Connecticut warbler.

Not surprisingly, the city is moving quickly to build more of these shoreline parks up and down its coastline. These spaces appear as delightful green necklaces around the city. And one day, they may serve as life preservers. These marshy, uneven edges along the shoreline parks may look wild, but they were intentionally constructed to help retain water when the next Superstorm Sandy comes. In this way, these parks provide a whole different kind of peace of mind, a super-absorbent reassurance against the anxiety of climate change. They are a contingency plan, a first line of defense against rising sea levels.

Looking around town, New York City has a number of other opportunities to make this an even greener and wilder place. Yes, these projects will require investments, sacrifices, and some creative thinking. But the payoff won't just mean more wild animals. It will also mean a cleaner and healthier city for human New Yorkers too.

Manhattan

In Manhattan, the smallest and most crowded borough, there's not a whole lot of space available for parkland. Still, it has added hundreds of acres of green space in recent decades, most notably along its shoreline as well as in some previously abandoned places like the High Line.

One radical proposal, however, could transform the very heart of the island. It's called the Broadway Green Line and it would create a 2.7-mile linear park running from Union Square to Central Park via Broadway, linking Madison Square Park, Herald Square, Times Square, and Columbus Circle along the way. If developed, it would provide a lightning bolt of car-free open space full of cleaner air and happier pedestrians. It could also help with an already overburdened water management system. It's a dirty secret that any time it rains, city sewage mixes with rainwater and flows into the rivers and harbor. Replacing these miles of asphalt with bioswales (linear channels that capture and filter runoff) and soil would allow a significant amount of stormwater to be absorbed naturally, which among other things, would be great for animals whose habitats are just off the shore.

This plan is ambitious, all right, but since when has Broadway ever shirked from a dramatic turn of events? Greening the Great White Way won't be easy. But if completed, it would be a stunning second act for one of the world's most famous streets.

Brooklyn

Across the East River from Manhattan, over in South Williamsburg, the Brooklyn Queens Expressway (BQE) cuts a trench right through the heart of the neighborhood. Not only does this open artery repel pedestrians and sequester entire neighborhoods, it also emits tons of noxious fumes to nearby residents. The Friends of BQGreen group is hoping to staunch the belching highway's effect on the community by placing two square blocks of platformed park over the roadway, which would include a baseball diamond, wooded areas, places for people to relax, and a way for pedestrians to leisurely cross over the buried BQE. If successful, it's a model that could be repeated in Cobble Hill, the South Bronx, and several other places across the city.

Staten Island

There's maybe no more ambitious a greening plan than the one underway in Staten Island, where a former landfill—once the world's biggest—is being transformed into twenty two hundred acres of parkland—a size almost incomprehensible to New Yorkers. By comparison, Prospect Park is just over five hundred acres.

At Fresh Kills, a tidal creek will run through the heart of the park and be surrounded by four massive hills that once were—and, yeah okay, still sort of are—mountains of old garbage. Indeed, every bit of land above sea level is a covered-up piece of household trash. It's an engineering marvel and surely the best-case scenario for these decades' worth of junk, though arguably the most incredible feature of this former landfill is all the wildlife that has returned, including foxes, egrets, coyotes, grasshopper sparrows, and more, which are already recolonizing this recently hellish landscape.

Queens

Out in Queens, the QueensWay hopes to follow in the tracks of the High Line's success by converting over three miles of abandoned railbed into parkland. If seen through, it would dwarf its Manhattan predecessor by nearly three times and incorporate playgrounds, bike lanes, and much more. These unused tracks currently stretch across—and at times above—the city's biggest borough, connecting a half-dozen neighborhoods, some of which lack their fair share of parks. It's not even hard to imagine how this green strip would look in Queens—the vegetation is already visible on Google Maps. All it needs now is a little community buy-in and Parks Department magic.

Delaying this plan is a proposal to use these tracks to run trains directly from JFK airport to Midtown Manhattan—it's enough to make anyone who has ever had to drive to JFK during rush hour drool. The heavy traffic, a generations-old problem, can be traced to New York City's "master builder," Robert Moses, who favored car-centric solutions over public transportation in the twentieth century. But just because the city's past was dictated by a cars-first mentality does not mean its future has to be. Truly, there ought to be another way.

The Bronx

Every year in the Bronx, over two billion gallons of clean, fresh water from Tibbetts Brook are routed underneath the city streets away from its natural course in a century-old sewer that diverts the water instead to a wastewater plant on Wards Island. In response to this needless treatment, a coalition of planners and community members have floated the idea of daylighting Tibbetts Brook—that is, to resurface it aboveground, making it a visible body of water again. Currently, the brook enters the Bronx from the north by way of the eponymously named Tibbetts Brook Park in Yonkers, New York. The new plan would have the water bypass the sewer tunnel at Van Cortlandt Park and instead flow south and eventually out to the Harlem River in a path that's similar to how the brook once flowed.

Daylighting Tibbetts Brook could also be a boon for local wildlife, as it would effectively create a green corridor from the Harlem River to Van Cortlandt Park. According to Steve Duncan, the urban spelunker who has chronicled sewers, tunnels, and other subterranean urban landscapes all over the world, including the Minetta Brook in Manhattan, daylighting Tibbetts could also provide relief to city sewage plants by removing from the mix more than five million gallons of water per day. That is not enough to fully alleviate the city's overtaxed facilities, but it would certainly help. "These efforts might just look like pet projects for environmentalists or people who like fish and eels," says Duncan. "In fact they're really good for the overall urban ecology, by which I mean the overall urban infrastructure as well."

In the end, none of these projects will be easy. But they are certainly worth the course-correcting effort. Daylighting buried waterways, especially, offers a unique chance to square mistakes made in the past. Rivers and streams, thoroughfares of life and energy, were paved over because they were foolishly thought to be inconvenient. Yet there is hope at the end of these sewer tunnels, a glimmer of redemption just down the stream. New York City can make things right again, both for wildlife and humans, but only once its past mistakes are addressed in the light of day.

Epilogue

Wildlife in any city is surprising. But the fact that these stories all took place in the five boroughs of New York City, the concrete jungle, is truly remarkable. After all, this is not just any old city. It's *the* city: these animals are coexisting alongside over eight million humans, or roughly 2.5 percent of the entire US population. There are more people living within the New York City limits than in all of Wyoming, Vermont, Alaska, South Dakota, North Dakota, Delaware, Montana, Rhode Island, New Hampshire, and Washington, DC, combined. New York City's wildlife is proof that environmental regulations can coexist with the market demands of Wall Street.

Some of these animals might even have it better than the human New Yorkers. Many are fast and strong. Most are ruthless and cunning, resourceful and clever. Some are killers. All are lovers. Some soar above the water, crash in the waves, or perch atop our highest peaks. Others wisely leave for the winter. Many have a view most humans would wait in line to see. Best of all, none of these animals pay rent.

And though they live alongside us, these critters keep to their own schedules with no regard to our busy lives. Whales come in the warmer months. Migratory birds pass through in the spring and then again in the fall. In a city plagued by delayed trains and traffic jams, there is something so comforting in the reliability of wildlife.

And yes, seeing a wild animal anywhere is a thrilling experience. But in the city, it can be magical, mostly because it demands patience. It requires us to pause, be still, remain quiet, and give our full attention, things that are rather antithetical to being a New Yorker.

The mere pursuit of viewing wildlife, even when we don't see any actual animals, acts as a welcome antidote to the onslaught of stimulation that comes with living in New York City. As Steve Baldwin of Brooklyn Parrots says, "We need a break!" We need something other than asphalt and hard right angles. We need fresh air and open spaces. It's great for wildlife, but it's pretty great for people, too.

Or as Audubon Society's Gabriel Willow reminds us, "When we examine what benefits humanity and what benefits wildlife, nine times out of ten they're the same thing." Looking ahead, New Yorkers should continue to care for the local environment—if not for the animals, then at least for ourselves.

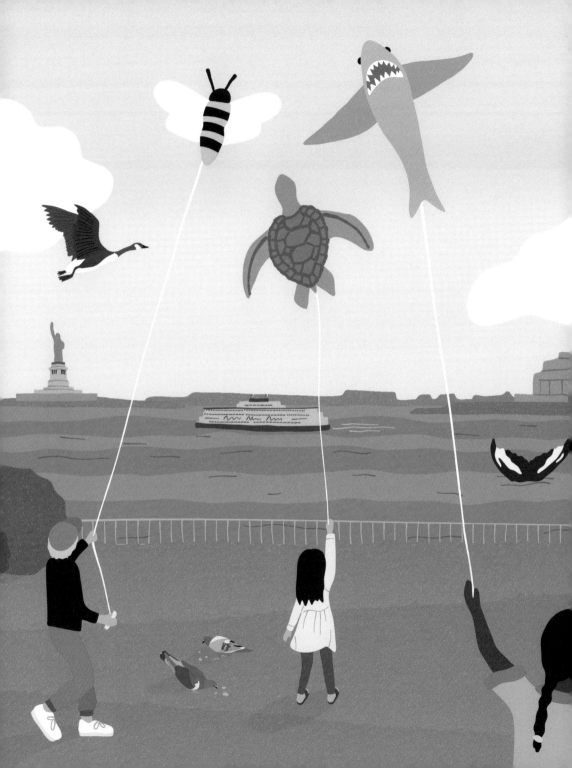

Resources and Further Reading

Sanderson, Eric. *Mannahatta*. Abrams Books, 2009.

Steinberg, Ted. *Gotham Unbound*. Simon & Schuster, 2014.

Shorto, Russell. *The Island at the Center of the World*. Vintage, 2004.

Kieran, John. *A Natural History of New York City*. Houghton Mifflin, 1959.

Day, Leslie. *Field Guide to the Natural World of New York City*. Johns Hopkins University Press, 2007.

Jacobs, Jane. *The Death and Life of Great American Cities*. Random House, 1961.

Kadinsky, Sergey. *Hidden Waters of New York City*. Countryman Press, 2016.

Carson, Rachel. *Silent Spring*. Houghton Mifflin, 1962.

Lopate, Phillip. *Waterfront: A Walk Around Manhattan*. Anchor Books, 2004.

Caro, Robert. *The Power Broker*. Vintage, 1974.

Bloomberg, Michael and Pope, Carl. *Climate of Hope*. St. Martin's Press, 2017.

Waldman, John. *Heartbeats in the Muck*. The Lyons Press, 2000.

Rogers, Elizabeth Barlow. *Green Metropolis*. Knopf, 2016.

Gallagher, Leigh. *The End of the Suburbs*. Portfolio, 2013.

Sterba, Jim. *Nature Wars*. Crown, 2012.

Kurlansky, Mark. *The Big Oyster*. Random House Trade, 2005.

Blechman, Andrew. *Pigeons: The Fascinating Saga of the World's Most Revered and Reviled Bird*. Grove Press, 2006.

Borel, Brooke. *Infested: How the Bed Bug Infiltrated Our Bedrooms and Took Over the World*. University of Chicago Press, 2015.

Rendell, Luke and Whitehead, Hal. *The Cultural Lives of Whales and Dolphins*. University of Chicago Press, 2014.

Winegard, Timothy. *The Mosquito*. Allen Lane, 2019.

Croke, Vicki Constantine. *The Lady and the Panda*. Random House Trade, 2005.

Kolbert, Elizabeth. *The Sixth Extinction*. Henry Holt and Co., 2014.

McNeur, Catherine. *Taming Manhattan: Environmental Battles in the Antebellum City*. Harvard University Press, 2014.

Daly, Michael. *Topsy*. Atlantic Monthly Press, 2013.

Daley, Robert. *The World Beneath the City*. J.B. Lippincott Company, 1959.

Rowland, Tim. *Strange and Obscure Tales of New York City*. Skyhorse, 2016.

Shulman, Robin. *Eat the City*. Crown, 2012.

Sieswerda, Paul. *Sharks*. Cavendish Square Publishing, 2001.

Sullivan, Robert. *Rats*. Bloomsbury, 2004.

Mittelbach, Margaret and Crewdson, Michael. *Wild New York*. Three Rivers Press, 1997.

Devillo, Stephen Paul. *The Bronx River in History & Folklore*. The History Press, 2015.

Hand, Jamie, Orff, Kate, and Brash, Alexander. *Gateway: Visions for an Urban National Park*. Princeton Architectural Press, 2012.

Coté, Andrew. *Honey and Venom: Confessions of an Urban Beekeeper*. Ballantine Books, 2020.

Cade, Tom and Weaver, James. *Falcon Propagation: A Manual on Captive Breeding*. The Peregrine Fund, 1983.

Alexiou, Joseph. *Gowanus: Brooklyn's Curious Canal*. New York University Press, 2015.

Stirling-Aird, Patrick. *Peregrine Falcon*. Firefly Books, 2012.

Richardson, Justin and Parnell, Peter. *And Tango Makes Three*. Simon & Schuster, 2005.

Winn, Marie. *Red-Tails in Love: Pale Male's Story*. Vintage, 1998.

Acknowledgments

Special thanks to NYC Audubon Society, GooseWatch NYC, the Riverhead Foundation, the American Museum of Natural History, Green-Wood Cemetery, Brooklyn Grange, New York City Beekeepers Association, Billion Oyster Project, Bronx River Alliance, Freshkills Park Alliance, Brooklyn Bridge Park, Gotham Whale, Brooklyn Historical Society, New York Public Library, The Peregrine Fund, Brooklyn Cat Cafe, Gowanus Canal Conservancy, Gotham Coyote Project, Dr. Dylan Yeats, Heather Wolf, Gabriel Willow, Michael Miscione and everyone else who agreed to speak with me for this book.

Extra special thanks to Dr. Cait Field who provided a behind-the-scenes tour of Freshkills Park; to Richard Simon of New York City's Wildlife Unit and Paul Sieswerda of Gotham Whale, who both consulted on several chapters; to Steve Baldwin of Brooklyn Parrots, for showing me how unexpected and delightful urban wildlife can be; and to Rita McMahon of the Wild Bird Fund, for her tireless work on behalf of the underrated pigeon, New York City's most amazing bird.

Countless books and articles informed the research done for this book, including work done by Jane Jacobs, Rachel Carson, Robert Caro, Eric Sanderson, Ted Steinberg, Mark Kurlansky, John Kieran, Jim Sterba, Elizabeth Barlow Rogers, Brooke Borel, Russel Shorto, Robin Shulman, and numerous others.

This book began as a series of articles published across five publications, to each of which I owe a debt of gratitude. Special thanks to Michelle Young of Untapped New York for taking a chance on the first few articles; to Raphael Pope Sussman formerly of *Gothamist* for pushing me as a writer; to Wendy Becktold of *Sierra* for allowing me to align my name and writing with that incredible organization; and to Silvia Killingsworth, formerly of *The Awl*, for agreeing to publish an article on falcons having sex with hats, which, while it may have cost me my job in public relations, also gave this series of articles the credibility and cache it needed to become this book.

Thank you to my publishing team: my thoughtful and wonderful agent, Sarah Smith, for seeing the potential in this project and working tirelessly to move it forward without ever compromising its true vision; my fantastic editor, Cristina Garces, for providing humor and a steady hand throughout this process, including, most notably, steering us away from including a full-page illustration of a dead dolphin in the Gowanus Canal; designer Jenny Kraemer of Studio Bueno, for making every page look awesome; and Kath Nash, the outstanding illustrator and artist who brought these images to life, and, in doing so, brought life to this book. It has been a joy to work with all of you.

Thank you to the Jefferson Market Library, the Brooklyn Historical Society's Othmer Library, Vineapple Cafe on Pineapple Street, Grounded Coffee House on Jane Street, and every other quiet room in the city where I was able to work on this book.

A shout out to seagulls, turkeys, wolves, and all the other animals that didn't get chapters in this book but are still very cool critters.

Thank you to my friends, family, and the people I met at weddings, bars, and parties, for letting me speak about New York City wildlife with increasing excitement over the course of several years. And, to that end, thank you to New York City for being the ever-surprising, constantly evolving, and unparalleled beauty that you are.

But most important, thank you to my very hot and very brilliant wife, Veronica. New York isn't New York without you, love. You have been unwavering in your support and patience. You gave this wild idea the space it needed to fly. You have literally made my dreams come true. And if I spend the rest of my life repaying this debt, I might get halfway to what you are owed. Thank you for Brooklyn Heights, Ladybug, and this ridiculously happy life of ours. But, most of all, thank you for secretly slipping your telephone number into my coat pocket late one night at Bar 169 on East Broadway all those years ago, which, as far as I can tell, is the most wild of all New York City stories.

About the Author

Thomas Hynes is a writer who lives in Brooklyn Heights with his wife, Veronica, and their dog, Ladybug. His work has been featured in *Sierra Club*, *The Awl*, the Travel Channel's *Mysteries at the Museum*, *Gothamist*, Business Insider, McSweeney's Internet Tendency, *PRWeek*, and Untapped New York.

HarperCollins books may be purchased for educational,
business, or sales promotional use. For information
please email the Special Markets Department at
SPsales@harpercollins.com.

Published in 2020 by
Harper Design
An Imprint of HarperCollins*Publishers*

195 Broadway
New York, NY 10007
Tel: (212) 207-7000
Fax: (855) 746-6023
harperdesign@harpercollins.com
www.hc.com

Distributed throughout the world by
HarperCollins Publishers
195 Broadway
New York, NY 10007

ISBN: 978-0-06-293854-1
Library of Congress Control Number: 2019060159

Design by: Studio Bueno

Printed in Thailand
First Printing, 2020